Engraving from the second year at the Ecole Estienne.
I envisioned myself already in my shop; I had chosen
the Saint-Germain-des-Prés district.

Three Seconds from Eternity

Photographs by Robert Doisneau

Translation by Vivienne Menkes

New York Graphic Society · Boston

International Standard Book Number 0-8212-1096-3
Library of Congress Catalog Card Number 80-19488

First published in France by Contrejour
First United States Edition

New York Graphic Society books are published by Little, Brown and Company.
Published simultaneously in Canada by Little, Brown and Company (Canada)
Limited.
Printed in France and the United States

The Golden Lion

I'm sure you'll be delighted to hear that I can't do a thing before I've had my first cup of coffee.

But in this bloody hotel they think you're impossibly demanding, not to mention unhinged, if you want a cup of coffee at 8 A.M. French hotels are wonderful, aren't they? I'm beginning to realize why the roads are full of trailers and vans darting about all over the place — they're driven by people traveling thousands of miles in their search for the *caffè negro, caffè solo,* or *cappuccino* that no one's willing to serve them on French soil!

So there I was twiddling my thumbs in the hotel lobby. No matter how loudly I shuffled my feet, cleared my throat, and moved the chairs about, still no one came and there wasn't even the faintest gurgling in the plumbing to raise my hopes of seeing the coffee wallah emerge.

I was so sick of the sight of the goldfish swimming ironically round and round its bowl and the smell of stale tobacco that I went out on the terrace.

When I'd got there the previous day the local fair had been in full swing, but now, with the flags hanging limply, it was hard to envisage the wild frenzy shown by the local populace, though the platform for the band was still there in the middle of the little square.

Actually scaffold would be a better word than platform for the place where the latest hits were being mercilessly executed. Not that they deserved a better fate, mind you, but the whole point is that the distance between the platform and my bed was about twenty yards. I ask you, wouldn't anyone be feeling grumpy in the circumstances?

I must have dropped off to sleep for a moment or two though, because I didn't hear the explosion and the mushroom cloud that wiped out the little town.

I heard footsteps and a man emerged at the far end of the square. So I wasn't the only survivor. He looked in good shape — wide awake and positively frisky. He was Japanese and he was taking his Nikon for a walk. He must have had two or even three cups of tea, lucky devil, to be able to keep up that sort of pace.

Look at him! Off he goes — takes aim — click! — turns around, steps back a few paces — click! Then he spots me and starts coming straight at me. When he's five yards away he stops, smiles. His eyeteeth and incisors are gleaming with gold fillings. I stand rooted to the spot. Click! Now I'm in the can too! And before I've had a chance to recover my wits he's vanished behind the twelfth-century church.

He'd just about finished me off, the wretch. Fancy getting up so early after a sleepless night only to be snapped up by a ravenous Japanese. My horoscope couldn't have been up to much.

The glorious light had finished clambering up over the roofs and was starting to move down along the housefronts. The sun presented every chimney, every dormer window, every gutter with the luxury of its own shadow. This carefully controlled form of lighting picked out every detail of the dozy little town to produce a lighthearted picture of it, breaking it up into a thousand tiny pieces and offering a new version as seen through a child's eyes.

Children's drawings do in fact have just this effect because their ever-lively curiosity affects the way they perceive objects. They think of drawing as a game in which they have to rearrange all the emotions they have experienced on the surface of their piece of paper, without bothering too much about a logical arrangement. When the early morning sun gives great emphasis to every object you feel that each one must have a story to tell. And at the same time it whets your curiosity and makes you feel you may be about to make a discovery.

So the function of early morning sunshine is to reawaken the unreasoning stirring within us mortals that gives us the strength to go on living — which only goes to show how well they organize things up above.

Not that all mornings are as glittering and confetti-scattered as that one. In Paris we're used to a diffused light which makes trees, houses, and tourist sights look as if they're all of a piece, with no details visible. The reason for this is that as soon as dawn breaks, the much-vaunted skies of the Ile-de-France spread out a grayish awning over the city for all the world as if they were slipping a loose cover over a valuable piece of furniture.

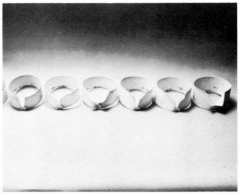

Collars of the respectable at the Thiers museum. The height of the collar indicates position on the social scale.

The light oozing out of this awning filters through a whole series of chinks and therefore casts an even light on all the different facets of each object.

As the various surfaces of a three-dimensional object face in different directions, some of them appear brighter than others, but none of them is really in shadow. The resulting lack of mystery produces a rational vision, somewhat cold and without the slightest hint of lyricism. When there aren't any creeping shadows to help you get your bearings, time seems to slip by very gently.

That's when passive contemplation takes hold of you, and then you start looking at things, a bit lethargically, with what is traditionally known as the wisdom of maturity. Which is almost the same as saying that dim light is the light of the wise. Anyway, wise men who also happen to be old have so little to say on this topic that they have to spin out their conversation by muttering: "Well now, that's how it is . . . that's how it is . . ." And that's how it was that a coffeepot made its appearance, borne aloft by a crumpled-looking girl offering living proof that *soubrettes* aren't necessarily charming.

Do you really have to get up at crack of dawn to present your fellow men with this basic principle: "The upward thrust of mood exerted on a sentient body wholly or partly immersed in a light is directly related to the quality of that light"?

The light that morning was quite definitely making a feeling of well-being thrust up within me. I found myself saying without thinking: "What a good time I'm having." But what was the point of offering my idiotic gratitude to a concept of duration that is completely indifferent? Time doesn't care two hoots whether I make complimentary remarks about it or not. There's no way it can be either good or bad. The way it gobbles up the hours makes your head spin. The answer is to adopt the system favored by the anarchists — starting again from scratch in each individual case. But anyway it's a waste of effort, so let's just pretend, it's such a nice idea.

The nicest idea of all, the simplest, is the spontaneous reflex action with which we try to hang on to a moment of happiness that's just about to slip away. Rather more premeditated is our attempt to snatch a picture as time races by and wave it triumphantly aloft as evidence that our own world exists. Such an attempt can also be sparked off by aesthetic considerations, in which case we say that the composition is harmonious because the various components that have no fixed place have arranged themselves as they think fit and taken on, for a fleeting moment, the familiar shape of a letter of the alphabet. This artistic refinement seems to me remarkably like a conditioned reflex.

For a long time I thought you had to concentrate all your efforts on slicing time into thinner and thinner slices, as though it were a joint of ham. But this gives disappointing results — if the slice isn't interlarded with a little bit of past and a tiny sliver of the future, all that's left on your wafer-thin slice is a mere gesture, totally without flavor.

André Hardellet has written some highly disturbing passages on this subject in which he compares the present to a thin pencil of light slipping along past events, while the events themselves remain motionless. As he sees

it — and he deliberately chose to seem retarded — the object of the exercise is to widen the pencil of light so that it becomes a well-trained instrument you can use for meditating on time.

If you fiddle around with time you'll never manage to shake off a vague feeling of anxiety, no matter how many slices of ham or pencils of light you use to help you. Which explains why photographers, panic-struck, fumble with their meager vocabulary and come up with nothing better in the way of magic formulae than the traditional: "Hold it! Hold it!"

And now my coffee's gone completely cold.

Heady Days

Lapses of memory are a marvelous excuse and are often used by old people as a way of palming off their dud coins. Keeping the drawers of your memory in a permanent state of untidiness is a deliberate policy. And it just so happens that the memories that are nothing to write home about simply can't be found, while incidents that give a boost to your self-esteem are right on the top.

If your old grandpa who's gone completely gaga says firmly and with supreme cunning: "The opposite of what I say isn't necessarily true," he disarms his potential adversaries and puts himself in a "heads I win, tails you lose" situation. But that's no concern of ours. For a start I'm not an old man — it was purely accidental when I crossed the threshold of middle age — and second, there are always my pictures, which pop up like so many frontier posts, preventing any attempt to slip away.

No doubt about it, I should have been a lord of the manor.

I can just see me strolling down the tree-lined paths in my grounds with my tutor, who's concentrating all his efforts on ensuring that the process of instilling knowledge into me is completely painless, like a blood transfusion. But fate decided otherwise. Instead of a stately home I had to cobble together my own "dunromin" in which I suddenly turned out to be a photographer. What I mean is that I had to earn my living by taking photographs, any sort of photograph, and not always at the most exalted level.

From Billancourt to Venice, from the Renault workshops to the Bestegui dance hall. I was in no danger of sinking into mere facility.

Do I wish it had been otherwise? Well, yes, of course I do, to a certain extent. It isn't easy when you're doing this kind of work to stop yourself going stale, to make sure that when you come to something better you'll be able to look at it with a fresh eye. All those hours in the darkroom drain off so much of your energy that you run the risk of sinking into resignation as well as learning patience.

They say that absolute freedom isn't a good thing and that the best resolutions emerge under constraint. In which case, since I've had my fair share of constraints, I should be thanking God that I wasn't born with a silver spoon in my mouth.

When I turn up old pictures that are gently yellowing at the edges I remember the various obsessions that have taken hold of me. First of all my ambition was to reproduce the skin of objects absolutely faithfully; then I wanted to unearth the treasures that lie hidden beneath our feet as we go about our daily business; then I was busy trying to slice time into waferlike slices; then spending my time with freaks; or trying to work out what makes some images specially endearing. And goodness knows how many other crazes I no longer remember.

But I'm afraid I may be making it all sound like a dilettante having a bit of fun — it's important to remember that I was under a great deal of pressure at the time to use my pictures to earn at least a subsistence wage. I've often lost the thread of my program because it was all mixed up with sheer material

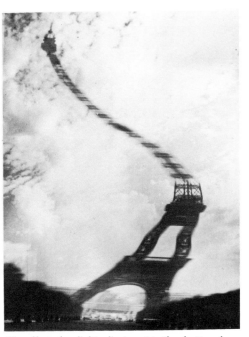

The effect of a slight adjustment to the shutter of a Speedgraphic camera.

need and interwoven with the happy and not-so-happy events occurring during that period.

It may look like a thin thread to you, but it can easily take up a whole lifetime.

Nowadays you're not really looked down on if you're a photographer — after all, some have managed to marry princesses. But when I started out a photographer was seen as at best a clever handyman who was tolerated provided he was willing to stay on the sidelines of the so-called real trades or professions. And when it came to the bigwigs of Culture with a capital C, they weren't standing any nonsense — you'd only got to mention the word "photographer" to have them forgetting their old quarrels and firmly closing ranks.

Even my aunt Zoe, the one with the la-di-da voice, would introduce me as "my young nephew who's a graphic artist," or "my nephew who's studying engraving."

Never "my nephew who's a photographer" — oh no! The poor lamb was always having to hang about on street corners and mix with layabouts, so no wonder he'd gone to the bad. As a matter of fact when my aunt said I was in engraving it wasn't a complete lie. I did study engraving, though study isn't perhaps the right word, at the Ecole Estienne. The idea was that you were supposed to cram the largest possible number of hatchings into the smallest possible space, using a special hinged magnifying glass. After a given number of days that seemed to drag on forever, you finished up with a stylized motif of intricate foliage with an angel all entwined in with it, or an allegorical figure, or the coat of arms of the city of Nancy.

The teachers, with their gray smocks, watch chains, and black felt hats, would congregate between classes to discuss the latest scandal about Van Dongen or the Salon d'Automne. "Honestly, he's just taking the mickey — green eyelids, I ask you! — so badly done — my six-year-old could paint just as well. Ah! Dagnan-Bouveret and his umbrella reflected in the parquet floor. Now what about Meissonier, he's head and shoulders above the rest of them."

And it took four whole years of learning the tricks of the trade and being steeped in culture before you eventually got your diploma.

People unconnected with the academy thought the diploma a great joke. No one went in for those outdated techniques anymore, except for a handful of craftsmen in the Marais. They juggled with their gravers and etcher's needles with the skill of acrobats, working incredibly fast because they were always in such a hurry to go and cheer on the horses.

And it was a horse too — a mare to be precise — that brought about a turning point in my life. She was called Uranie and she was unbeatable. So without further ado I handed over my wages for a week's work to a little man with a greenish complexion in the rue Saint-Claude. The wages were for a label for a bottle of claret. Wine labels are pretty small, but I'd somehow managed to squeeze in a panoramic view of the wine store and the medals the vintage had won at the 1889 Exhibition above the name of the château, which was inscribed in what is known as "Italian hand."

A former student had helped me get the label right, the same one who tipped me off about Uranie. And the miracle happened — that day Uranie, claiming she'd got a simply awful headache, my dear, stayed well back in the field. No doubt about it, I was being given some really rotten advice.

I was beginning to think that the training I'd received was a farce. None of the antiquated teaching seemed to be of any use whatsoever. For four whole years the only times I'd got away from the printing plate were when I'd gone to stand in front of a series of Greco-Roman busts, screwing up my eyes and holding a piece of charcoal at arm's length, the object of the exercise being to calculate the various dimensions. But what I found rather confusing was that at the same time they'd be whispering in my ear that you should never copy nature slavishly — otherwise photos and plaster casts would be works of art.

This trick photograph was simply made by sticking white-headed pins onto the black background.

The vogue word in those days was "stylization." When you were doing a decorative design you were supposed to stylize — such a vague term that you finished up with angular, symmetrical compositions with a welter of sepia tones, or black and gold.

All that poisonous, old-fashioned rubbish should have been shoved in the wastepaper basket lock, stock, and barrel. The only way to deal with a teaching method that was leading straight to a dead end was to do exactly the opposite — that way I was sure to finish up on the right road. What impeccable logic, I thought. And with the added attraction of disobedience, too.

I'd willingly have swapped the whole cupboardful of Roman emperors for the chestnut seller in the place d'Italie. None of the teachers would have given him so much as a second glance. He could perhaps have done with a shave, but for me he had the great merit of being a contemporary, and one who was well and truly alive.

Now that I'd moved over to the opposition and was ready to take my revenge, I decided that for centuries artists had been obsessed with the idea of accuracy. I was going to be an imitator, and what's more I was going to do it as conscientiously and accurately as I could. And to make the break even cleaner I was going to experiment with a neglected world, using a means of expression that was universally despised — photography. So there!

With my heart in my mouth I launched into a new and purely empirical form of apprenticeship. Which meant starting by reading very carefully the instructions inside boxes of photographic plates.

I'd read the most amazingly erudite books. But I'm not ashamed to admit that all this literature was pretty off-putting, though there was just one exception — a page in a book by someone called L. P. Clerc all about photographers and tobacco. Here's a bit of it: "The suggestion that photographers who are in the habit of smoking should use pipes with a special baffle cover can now be seen as an unnecessary precaution."

I was so keen to master the optico-chemical possibilities so as to get into their good books that I'd become the hardworking (and only) pupil in my own retraining center. "Sensitometry" — I was dazzled by the novelty of the word. There it was in black and white: "Nowadays no photographer with any claim to be an expert can afford to ignore sensitometry." Determined not to be an ignoramus to my dying day, I followed the book's advice and tracked down a "Filmograph."

It turned out to be a gadget painted black and it had a suitably scientific mien with its viewfinder and rheostats. When I sat down in front of it I was immediately reminded of an engraving of Louis Pasteur in his lab, which used to crop up regularly in primary schools. Cheered by his example, I bravely plunged in: along one side you put the decimal logarithms of the lighting — good! — then down the other went the optical densities — well done! Now all you had to do was join up the dots and you finished up with the characteristic curve of the emulsion in question.

But the trouble was that the shape of the curve seemed to vary from one piece of graph paper to the next. The instruction leaflet didn't mention this possibility, so there must have been something wrong somewhere. Or perhaps it was just that this was an age of specialization and I wasn't cut out for scientific research. So we went our separate ways — the Filmograph was dumped in the attic and I turned from theory to practice.

Eventually, after bringing off a few passable reproductions of materials that feel pleasant to the touch — textiles, shells, feathers, china, a mishmash of amenable subject matter — I felt bold enough to put my talents into practice.

At last I was going to be able to get one precious subject down on paper — the shaft of a lamppost. That lamppost was the first flower in a bunch made up entirely of street furniture. I was thrilled with my harvest — a heap of paving stones, iron gratings around trees, lamps hanging up around a building

site, manhole covers. And even now my sense of wonder doesn't strike me as ridiculous.

I looked at everything as if I were using a magnifying glass — a hangover from my engraving days. In fact a magnifying glass is the best implement of all for revealing the nobility of objects that have weathered or mellowed with use and the passage of time. Mind you, I was the only person who thought this. For a start, people don't really look. They'd pass by, weighed down under their problems, brooding on quarrels with their neighbors over common walls or some such thing they were always going on about.

I felt that no one understood me, but at the same time I was convinced that I was a superior being. Yet I'd never have dared raise my camera in their faces. Looking all innocent, I'd secretly give them a couple of quick slashes with my personal laser beam and transfer the resulting fragment of grotesque humanity on to the finest sensitive surface ever invented — a brand-new retina. Luckily I was too shy to translate this process into concrete action, so I waited till I'd reached a less aggressive stage. To be fair, a few grown-ups who seemed to have retained their critical faculties unimpaired offered me living proof that shyness or timidity can be overcome.

On election nights they'd come and throw stones up at my uncle's shutters, which explains why they weren't very popular in the circles I moved in. They were referred to as "cloth cap guttersnipes" and the police didn't exactly handle them with kid gloves. They'd stealthily stick up posters all over the place — they may not have been very artistic posters, but secretly I admired their cheek and their team spirit. I felt they were the only people who really wanted to change the idiotic props I could see all around me.

The net curtains, the felt soles you were supposed to use for polishing the floor, the fancy plant pots and the antimacassars in the dining room were bound to be kicked out when they put their program into action, along with the long list of "right-minded principles" — opening a savings account, having a short-back-and-sides haircut, being a good son, a good father, a good citizen, and ending up with a long-service medal pinned on you by your boss. But when I looked around at the pathetic faces of the people who'd put these principles into practice, I soon saw that they were as dull as ditchwater.

It was high time I gave such mean and shabby creatures a wide berth and set off somewhere, though I didn't quite know where. I wanted to find something so beautiful it would take my breath away. Anything would do — music, poetry, a strong belief in something. I was hungry for such luxury goods, but the local shops didn't go in for merchandise that wasn't intended for immediate consumption.

Among the people I knew it was considered sensible to make do with substitutes. Everything had to be leveled down to the lowest common denominator for the ordinary working man and woman; it had to be somehow flashy and it mustn't cost too much. So it was all imitation leather and fake wood. Scallop shells marking out flower beds, folding bedsteads converted into rabbit hutches, marrow bones turned into key rings.

Salvage was the name of the game, and the poets were salvaged along with everything else. Soaring flights of lyricism would be used for memory training. A rather painful exercise — no wonder schoolboys coined the term *poètes maudits*, "damned poets"!

Poets were also expected to do their bit in civics lessons by acting as a sort of guarantor for what we were taught, with Victor Hugo invariably as teacher's pet.

I was in the choir the day the war memorial was unveiled. The words were by Victor Hugo and the music by M. Levif, our singing teacher. There was a three-part chorus at least: *"Ceux qui pi-eu-se-ment sont morts pour la Patrie, ont droit qu'à leur cercueil la foule vienne et prie . . ."* All the children from the local schools were there, both boys and girls. We'd never rehearsed together — it would have been far too chaotic — but we put up a good show all the same.

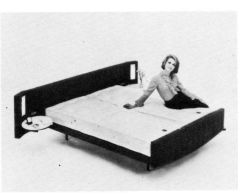

A lady on a studio bed stressing the qualities of a functional sleeping machine.

We all got to the pause at more or less the same time. Then the cover was whisked off and we could see a bronze widow showing her son a name carved on a marble tablet. The memorial was by M. Vasseur, whose father was on the local council.

I remembered the details of that morning very clearly, but that wasn't the sort of poetry I was after. And things were no better in the mystical rapture department — there was a flaw somewhere.

At first glance the priest at the church of Saint-Saturnin made me think of a glorified astronomer. When he started talking about "the Eternal" and "the Infinite" you could only see the whites of his eyes. On the whole the way he presented things was a good deal more appealing than all those sums about taps and filling baths we had to do outside church. I gradually found that his magic gestures were wrapping me in a sky-blue cocoon — it felt lovely — and I was gently floating way above the zinc rooftops of my suburb, carried away by the mood of angels and plaster saints.

But then everything was ruined. As I floated upward I found myself on a level with two notices saying: "God sees everything" and "Wicked children are denied God's love."

I recognized the handwriting of the lady teacher who used to tell us, gazing modestly at the ground, all about the wonderful things our distant ancestors got up to. The way she described it, you'd think the Eternal Father had nothing more important to do than check on whether small children were clean and decent. Worrying about the sex of angels suggests a finicky approach to life quite unworthy of a Father Eternal who's supposed to be infinitely good and infinitely kind.

I promptly started feeling highly suspicious. Monsieur l'Abbé was much too aggressive when he joined in ball games. And what about the rear-view mirror off a motorbike he'd fixed to one side of the tabernacle — what was it for? To keep an eye on his flock or to make sure his own raptures were under control? The spell was broken. I shall never know the undiluted thrill of bawling out hymns beneath Romanesque vaulting. And I almost forgot to mention that his breath smelled all musty too.

If it hadn't been for these small points I might have been an unwavering supporter of the religious status quo by now.

Don't let's start wallowing in regrets over what might have been. Let's go back to photography instead. It's so hard to shake off childhood memories. You know how it is, one word leads to another and in no time you find you've wandered off the point. So where were we before that little digression? Oh yes, we were talking about passersby acting as if they were part of a grotesque puppet show, and about being shy.

Following the same path as had led the earliest film directors to use stagy gestures in front of the cameras, I came to the conclusion that the walking caricatures I could see all around me were the best possible models for a photographer. I knew a fish tank near the porte de Saint-Ouen that was teeming with a whole crowd of extras straight out of a pirate film. All I had to do was dip in my net and fish out a few specimens.

So I cheerfully plonked my tripod down and screwed a wooden camera onto it. Now hiding your head under a black cloth doesn't necessarily make you invisible. I learned this simple truth when I'd finished getting the lens into focus and came up for air. All the characters doing the three-card trick were looking at me, standing stock-still just as if they were waiting to be photographed. Someone said: "Hold it, Paulo!" Paulo came toward me and I had the distinct impression there'd been some sort of misunderstanding.

I realize now that if all had gone as planned, Paulo must have been expecting to regale his audience with a circus act, with me as high-vaulting tumbler. But he must have decided I wasn't in the right weight category and in spite of his admirable respect for sporting categories he expressed himself in the

coarsest possible terms. I don't remember exactly what he said, but it was something to the effect that he'd never seen such a fool and that it would be in my best interests to go and play in my own backyard, and a whole string of other less important comments.

I carted off my equipment to a spot a bit farther off. It hadn't exactly been an auspicious beginning.

It seemed as if reality, when seen at close quarters, was rather rougher than I'd expected, and you obviously had to learn by experience how to come to terms with it. For the next three or four Sundays I brandished my black cloth at the flea market, and managed not to tear it. The results were published in a magazine called *L'Excelsior* — I had the whole of the back page.

I could already picture myself looking like the reporter on a poster for the *Petit Parisien* newspaper, wearing knickerbockers and with one foot planted firmly on a globe.

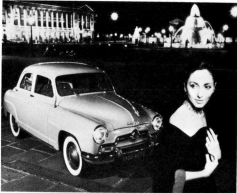

Yet another photograph glorifying the car, enwrapped with a sophisticated charm.

The Bièvre, a river that has now been taken over by the Sewerage Board, flowed beneath my suburb. In the old days, fifty-odd years ago, you could see a thin trickle of an evil-smelling and vaguely brownish-looking substance seeping out beside the leather-dressing factories. That was the Bièvre.

In the lower-lying parts of the town the walls were so full of saltpeter rot you could draw splendid graffiti in the soft plaster just by using one finger. The streets around the church were crooked and full of nooks and crannies with pipes and bits of plumbing sticking out all over the place. Special drying racks jutted out above the rooftops like watchtowers, with skins hanging from them, while up on the heights in the direction of Montrouge little detached houses reigned supreme, each with a flight of steps leading up to a glass porch, and wrought-iron railings that were given a new coat of paint every spring.

No need to complain about a lack of open spaces, with all those market gardens, plus the added bonus of the sweet smell of celery. And then there were the wide open spaces too, the patches of waste ground that would be referred to as "adventure playgrounds" or some such thing nowadays — the term hadn't been dreamed up in those days, of course. No wonder people felt the need to get all this clutter into some sort of order, to convert it into a functional tool. Well, ladies and gents, they've done it. And there it is, large as life and hideous.

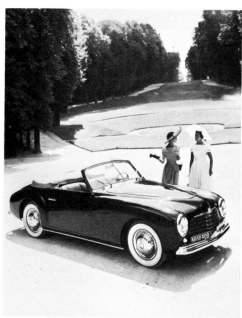

Departure for the concours d'élégance. *With a convertible and such light bonnets, prudence dictated that the photographs be taken prior to the departure.*

In the old days this preposterous backdrop had the merit of setting off the human beings who were walking about in front of it. Not the old folks — they'd somehow grown to look so like the landscape they simply blended into it — but the youngsters. You had to have a fair amount of cheek to come back from the woods outside Paris with your bike covered in daffodils and plunge straight into this gray twilight. The girls had the most brazen cheek. Slag-heap flowers taking their brand-new breasts for an airing in the sinister rue Frileuse. Pretty shepherdesses from Gentilly who'd go off to Robinson on Sundays to dance the tango with their shop-assistant princes. But there was no one to notice these beautiful young creatures — honestly, people don't deserve to have eyes.

And then I turned up with my camera, a Rolleiflex, which came from another suburb, in Germany this time, a suburb of Brunswick.

Working on Sundays or when I was playing truant from work I tried to record this absurd backdrop and to join the crowd of extras. I gradually got together a whole collection of pictures, and I felt reasonably pleased with some of them. But I felt terribly alone. My friends and acquaintances showed no interest whatsoever in my photos of life in an ordinary suburb. Not surprising really, considering they were suburbanites too.

I started having doubts. Supposing I'd gone completely off the rails? I felt the need of an expert opinion. Now in those days there was a lady photographer, a real *grande dame*, whose success and the deference shown to her

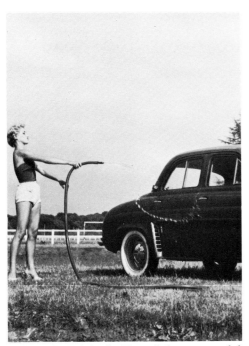

In the guide "Driving for Women" the recommended car care proved to be not incompatible with elegance of gesture.

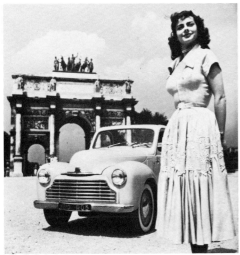

Miss Fabienne dressed by Carven. Five-horsepower styled by Simca.

were such that she could enjoy the luxury of being kindly to all and sundry. I plucked up courage and asked if she'd agree to see me.

I remember that her flat was a bit cluttered for my taste, crammed full of plants and busts and heavy lace trimmings that produced an overall atmosphere which was both solemn and ultra-cosy. I kicked off by sitting on a book that was lying open. Then after a moment's hesitation I unwrapped my masterpieces. Spread out on the velvet-covered divan the 18 x 24 prints looked so pathetic it seemed like a terrible presumption.

The lady photographer reacted like someone lighting a joss stick to ward off an evil smell, rushing off to show me how it should be done. She left me alone for a moment and I took advantage of her absence to gather up my photos, which seemed so incongruous in these surroundings. When she came back with an armful of huge prints she was all smiles. I was immediately struck by the wide margins, and by the authoritative-looking signature, and then by the velvet mount. I can't exactly remember what the subject matter was, but it could definitely be classified as "pictorial." I backed out of her presence, bowing politely.

To give you an idea of what I'm like, let me tell you that this visit cheered me up no end. As soon as I was outside her door I felt quite sure I was on the right track.

Then, to give me a chance to see what life was like inside the factories busy whirring away all over the suburbs, Fate allowed me to enter the finest of the lot — the Renault factory in Billancourt.

I was taken on as an industrial photographer. To the delight of my employers, it didn't take me long to learn the ropes and I soon knew how to take a decent portrait of a Cazenave lathe or a Cincinnati milling machine. The only way I could take this type of photo was with an 18 x 24 camera. This, plus a suitable stand, the plate holders, and all the various odds and ends I needed, weighed about twenty kilograms altogether. I'd wander through the streets and the workshops weighed down by all this paraphernalia with a slogan running through my head that was used on all the ads: "The Renault factories cover the same surface area as the whole of the city of Chartres." And I daresay they did too.

Occasionally the daily routine was broken by the odd commission that took me quite legitimately outside the factory. I've got happy memories of such occasions. For instance, every now and then an oil king would visit Paris and I'd find myself outside the Hôtel Crillon, in a scrum around the much-vaunted Reinastella, meeting experienced photographers for the first time. More often I'd be after an advertising shot. With eight passengers seated comfortably and all facing the front, all geared up for action, we'd set off for the parc de Saint-Cloud with a Vivastella crammed with the slimmest typists from the mailroom.

I've saved the best bit till the end — the *concours d'élégance* in the Bois de Boulogne, which took place in June. Vivasports with their roofs rolled back, the dazzling beauties with their hooded capes, which rose up every time they accelerated, the white greyhounds, and the chairman of the judging committee, M. André de Fouquières, who would greet them with the words: "And here now are Beauty and the Beast," busily kissing her hand.

Everyone was dressed up to the nines, seeming very relaxed and at ease, and no one thought of looking up to see the smoke rising into the air above Billancourt. After I'd been walking on air for a few hours some of the workshops seemed even grimmer than before — the forge, the painting shop, the tire section, the heat treatment rooms, for instance. You'd often come across a tyrant of a supervisor yelling at everybody and managing to make life in the workshops even more unbearable. During the 1936 strikes the manager who was in charge of one factory was flung into the Seine a good dozen times. Or rather an effigy of him was.

The magnesium flash would give the whole workshop a welcome break.

One 50-gram flash — bang! — and fifty guys would be doubled up with laughter. The photographer's good deed for the day. But don't think all this was just a brief interlude in my career — I stuck it out for five years. I was very good at dozing in the works bus in the early hours alongside my work-mates.

Sometimes I'd find myself daydreaming. "You're wanted in the visiting room." And there was just the man I needed and he'd be saying: "I've heard about your color prints, how absolutely wonderful. Do come at once, my chauffeur's waiting for you."

I had in fact been plotting my escape by secretly perfecting a new printing process, working away every evening in the kitchen at home.

I can't see any objection to revealing my secret formula now. You start by making a tricolor separation of your subject. With the resulting negatives you isolate three gelatins which have previously been tinted with primary colors and stuffed with bichromate. Now listen carefully: you peel off the gelatins in a lukewarm solution of disinfectant and wood shavings and then transfer them onto celluloid polished with beeswax and paraffin. All you have to do is to proceed as with a transfer — you transfer the three pictures onto the final background following the sequence yellow, red, blue, and making absolutely sure you get them in perfect register. At least that way you can be certain that the finished picture won't be a slavish copy of the original!

I've still got just one of the photos I concocted in my darkroom-cum-kitchen. I suspect it gives a pretty good idea of how people with very poor and blurred vision see the world around them. The point of inflicting this tedious description on you is that I want to try to make you understand how impatient I was to become a free agent.

One man did eventually become aware of my deep-seated aspirations and showed me the way out — the personnel manager. His reason was that I was consistently late for work. I was overjoyed to be back on the streets where there was so much to see, though I did also feel vaguely apprehensive. Five years in a factory tend to stifle initiative. But even if I had grown a bit soft I simply had to get weaving if I was to keep body and soul together.

It's odd, isn't it, how every time you try to take off on some new venture you always find there's something lurking in the shadows ready to hit you over the head? It was the summer of 1939. Not exactly the most auspicious moment to feel a need to share my breathless wonder with others, and it wouldn't be for quite a few seasons to come. My plans to become a keen photographer had to go into cold storage for the time being, because there I was, rigged out in puttees, in the light infantry.

From now on my main priority must be to make sure that my exceptional vision wasn't destroyed forever, though the powers-that-be didn't seem to give a damn about it. Even if they'd been told, I doubt if it would have made any difference. It wasn't exactly a time for sentimentality. Mind you, I didn't feel they put their arguments across very well: "You can't make an omelet without breaking eggs"; "you know how much they managed to achieve, those little chaps in berets, very much the gentlemen, and pugnacious as they come"; "the great names carved beneath the sacred arch." He'd said all that, the colonel had, to make us want to go out and fight. You might say he was offering us a retraining course.

It's important to have an overall picture of the events you've lived through, but somehow, perhaps because I've been trained to work with a magnifying glass, my personal cinema will only screen tiny fragments of memory, depicted in such detail that I have to restrain myself or I'd be launching into anecdotes every five seconds.

There's some excuse for wanting to relive the past, but the little twerps sauntering about now wearing the most awful army cast-offs and the vilest badges and insignia don't realize, ignorant fools that they are, poor little calves on the way to the slaughterhouse, that if they really want to look the

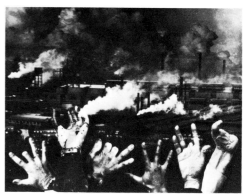

Symbolic photograph: industrial accidents. A montage made with great respect after a visit to the Thionville steelworks.

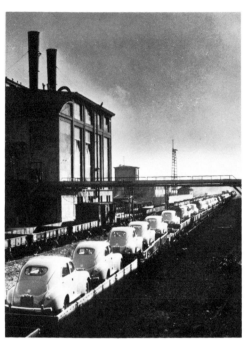

All serious industrial reportage must traditionally finish with a shot of the dispatch section.

part they need an air-raid warden's whistle, a blue lantern, a ration book, a permit allowing them to travel in and out of the occupied zone, a yellow star, a red warning poster, and a sheet of instructions telling them how to use a damp stone and a mauve pencil for duplicating. A slimy sort of sadness oozes out of all this junk, and I really feel that it's totally inappropriate in the ready-to-wear trade.

Vegetables cost astronomical sums on the wartime black market, yet men came absurdly cheap. If everything went really well and when it was all over you'd lost nothing worse than a few years of your youth, you reckoned you'd been damn lucky. People were so thrilled to find they were still in the land of the living that they went slightly off their heads. Some of them could be seen going down into cellars saying they were going dancing.

The printers were in pretty poor shape too and went absolutely frantic. They were like people suffering from withdrawal symptoms — they simply had to have their fix of illustrations, any old illustrations, produced any old way, really fast. This atmosphere resulted in a whole series of pictures in very poor taste, which meant thoroughly healthy pictures, produced in such a cheerful, lighthearted mood that I can't find it in me to feel any remorse when I turn up one of the papers or magazines of the period. After so many years of being stifled, all of a sudden there was this great gust of excitement. No doubt about it, it's hard to stick to your resolutions in that sort of atmosphere.

But what exactly were my resolutions? A letter arrived to refresh my memory. The handwriting was all spiky and disjointed, and it read: "I'm absolutely thrilled by the photos of the suburbs and suburbanites." I'd given up hope of ever being paid a compliment like that. It was the only one, mind you, but it came from the poet Blaise Cendrars.

I'd met him in Aix-en-Provence, at the barber's. His voice came through the lather as he told the apprentice all about the fifteenth-century soldier and adventurer Gilles de Rais — and the poor lad stood there gaping, his razor in midair.

We went to his home in the rue Georges Clemenceau. He made me drink a large glass of rum, which is bound to make you feel pretty warm inside if you're not used to it. And he told me about walking with Fernand Léger in the slums on the outskirts of Paris, between Villejuif and Arcueil, and how Léger had been beaten up by a gang of gypsies. And no wonder, in that jungle. I knew what it was like because I'd taken some pictures there, and it shook me out of my lethargy. It's terrific to find yourself in Aix-en-Provence talking lyrically about Villejuif — usually it's the other way around.

I promised to send him some pictures. "You'll soon see it's hardly changed at all, honestly it hasn't!" "No, no! That's the cupboard, this is the front door!" And bang! — off I went to sleep under an olive tree.

I was so delighted to have found such a grand soulmate that as soon as I got home I sent him a whole sheaf of pictures I'd gleaned on the hilly ground overlooking the Bièvre. And now I'd got this highly enthusiastic letter! And he was looking for a publisher! And he "held out a friendly hand to me," in his own traditional phrase.

Blaise Cendrars has always been very good to me. My family originally came from the Beauce area southwest of Paris and he insisted on thinking of me as one of the descendants of the men and women who built Chartres Cathedral, which was damn flattering. Goodness knows what made him say this, but who cares about evidence — maybe he was right. The book was eventually published, by Delatte in the rue de la Pompe — and with great pomp and ceremony too. All sorts of distinguished people came to the launching party. Some bibliophiles came clutching all the first editions from their collections to talk Blaise into autographing them. Some people will always take advantage, won't they?

But it was a really exhilarating evening all the same. Not that it was much of

a success from the sales point of view — the book never went into a second edition. That was in 1949. Thirty years later, on the principle of running a ruler backwards and forwards under a cupboard to find an old cuff link, galleries, libraries, and museums are asking me for illustrations from that first book.

But in this particular case, I have to admit, it would be an exaggeration to talk about a smash hit.

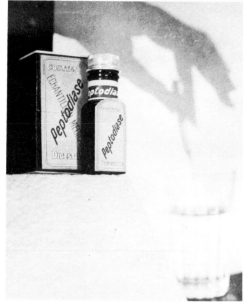

Pharmaceutical publicity in 1930: explicit to the borderline of permissiveness, it was nonetheless accepted by the laboratory.

In the Lemon Squeezer

Nowadays becoming a photojournalist is relatively easy. First you touch Granny or Auntie for the cash to buy all the paraphernalia, then all you have to do is push open a door that's already ajar. Making a living from it is another matter, of course.

In the old days, before you could get into the trade you had to get past a whole lot of legendary dragons who didn't give intruders a chance. The champions wore an armband with the word "PRESS" embroidered on it to prove that they belonged to a secret society. They were the visible members of the brotherhood, like the periscope of a huge submarine.

"You've never done any press work, so you can't get into the press . . ." It was an unanswerable argument and the physical presence of the group meant there was no point in even discussing it. They always formed a very closely knit group, whether they were on the steps of the Elysée Palace or standing by the Tomb of the Unknown Soldier, and the equipment they used forced them to maintain strict discipline, of the kind used to ensure that execution squads carry out their duties efficiently. If you wanted to join the group you had to have a whole sheaf of passes all the colors of the rainbow — press passes, permits of various kinds, badges and so on, all of them stamped and counter-signed and obtained by some mysterious process.

All of those had to be carried in your pocket. But you also had to carry other things in your head, neatly filed away in your memory — clichés that had stood the test of time, a whole series of commemorative props ready to be whisked out at the appropriate moment. For instance you were supposed to know that the women's motor race from Paris to Saint-Raphaël was always illustrated by a picture of a lady looking into the rear-view mirror of her sports car as she put on her lipstick. It had to be that one picture — nothing else would do.

And then again, on 25 November, Saint Catherine's Day (Saint Catherine is of course the patron saint of unmarried women), the done thing was to get hold of a *catherinette*, an unmarried girl of twenty-five or over, to drag her off to the rue de Cléry, to borrow a stepladder from the bistro opposite the statue of Saint Catherine (they were quite used to lending it), and get the girl to climb up and offer the statue a bunch of flowers you'd thoughtfully bought beforehand, giggling the while.

But the pick of the bunch of these traditions was the sprig of lily of the valley traditionally presented to people on May Day. And the key scene, my own favorite, showed the sturdy market porters in Les Halles presenting the president of the republic with his little bunch of lilies of the valley on the first of May.

Oh, those worthy fellows in their time-honored leather hats! The complicity that sprang up between the market porters and the press photographers wasn't pure chance, I suspect — in both trades you could find the same team spirit, and the same pride in practicing a trade as though they'd been awarded an honor.

They got so used to finding themselves with the people on the far side of the crush barriers that they started identifying with the VIPs. Without realizing it

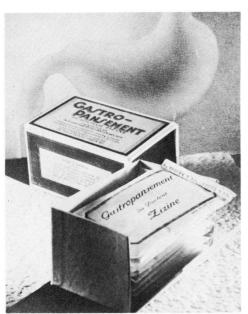

Another publicity photo for a product to relieve stomach upsets. Note the economy of style with which visceral ills are suggested.

they adopted an élitist attitude which meant, needless to say, that they felt mildly contemptuous of the masses. This familiarity could at times, in the heat of the moment (so we can forgive them), lead them to call some of the important personages by their first names. But it didn't happen often.

Journalists had the same condescending attitude toward photographers as staff officers are liable to have toward a front-line infantryman. Their condescension was never malicious, but there's no doubt that all those funny stories in which a photographer commits some clanger were spread by journalists.

Photographers have been called "the infantry of the information media." Not a bad phrase, that — there they were, out in all weathers, rain, wind, or snow, with their toolbox. Apart from that they weren't too cluttered up with technique. Not that they called it technique in those days — "the tricks of the trade" was the phrase used. In fact you had to be pretty nimble to use all that machinery properly, what with the wooden front of the camera ("guaranteed extra-dry") offset by a pure nickel back with a magazine with a drawer for changing the plates (just the job for making ground glass!). And they calculated distances and light by guesswork. They really ought to have been awarded a diploma for managing to handle all that paraphernalia properly. After all, that was just about everything they needed to know on the technical front.

Nowadays no apprenticeship is needed and rationally designed cameras produce technically perfect pictures apparently without effort. As a result you have to put a great deal more effort into taking pictures if you want to win the admiration of your contemporaries.

The important thing for a photographer trying to offer a new angle is to capture an observation post. You can use various different methods to get yourself up to your new eyrie — your life-style may do the trick, or you may have useful contacts to pull strings for you, or your position on the social ladder may be effective.

Supposing — it's highly unlikely, I admit, but just supposing — the French president took a series of portraits of his fellow guests at an international conference and they turned out well. All the magazines would be after them and it would be a real scoop for the one that managed to publish them. And just supposing the other heads of state were infected by the same itch and decided to compete with him, turning the supersummits into photo safaris — perhaps the fate of the world would be changed for the better!

But we've wandered well away from those rustic pioneers we were talking about.

I've probably made too much of the complacent attitude of our predecessors when they were *en masse* — after all, the same is true of any period and any clique. To make amends let me pay tribute to the patience they showed in putting up with the most uncomfortable situations.

And I must say that if you took one of them aside he'd willingly offer a piece of advice: "In vile weather like this, my lad, you want to screw to the size of a ten-*sou* piece and keep the brake on . . ." Which meant in plain language an f/8 diaphragm setting and slowing down the speed with which the roller-blind shutter came down by leaving your thumb on the wheel.

Once the plates had come out of the magazine they were handled pretty roughly. The prints were often made while the plates were still wet and would, wherever possible, be sent to the retouching studio, from which they would emerge with the black areas emphasized and the white areas heightened with the chalky look of the women who take your money when you visit a zoo. When the pictures eventually emerged from the rotary press and were strewn through the text they made each page look really pleasing to the eye, like currants in a piece of cake.

It all went like clockwork. With everyone knowing his function and his limits, the situation never got out of hand.

It was at this point that a handful of iconoclasts appeared on the scene, some of them from as far away as Hungary, or so it was said, creeping in like jokey conspirators and claiming they could take pictures with gadgets that were barely good enough for amateur photographers. A laughable idea — one to be soundly squashed by the pros.

Anyway, they said, why worry? When the cops see those jokers coming they'll throw them out on their ear in two seconds flat. This was fairly sound reasoning — the presence of photographers humping huge great cameras about at an official event acted like a seal of approval, guaranteeing that it was an important occasion and at the same time adding a touch of dynamism to the ultraproper atmosphere. Sure enough, the troublemakers were thrown out. It may well be that after several failed attempts they started thinking along the following lines: "Those officials who are so anti us are only to be seen laying down the law at totally unimportant events. So let's go and see what's happening elsewhere."

They sought out new pastures and found a world rarely visited by photographers. And they came back with an armful of disconcerting pictures, revealing an exotic new world only a few metro stops away.

Once people have started questioning the status quo anything can happen. So why not set up a Photo Liberation Movement with strict orders to refuse to obey the commandment that runs: "Just be your pretty self and shut up!" Photos had had enough of acting the part of *soubrettes* and wanted one of the leading roles for a change, even to the extent of aspiring to modify the news presented.

Whatever next? Well, next came a magazine called *Vu*, started in 1930 by Lucien Vogel.

New equipment, a new recruitment policy, a less rigid approach to taking pictures, and designers and layout people eager to outdo their rivals — the new magazines all had these, but what (or who) exactly was it that made them what they were, full of clever ideas? After all, what was so stimulating about them was that you were witnessing a complete metamorphosis of illustrated papers and magazines.

But don't let's get carried away. There's no getting away from the fact that this first burst of enthusiasm soon lost its buoyancy and press photographs are now mostly used in very humdrum ways.

Did you realize that even now you can see photographers jostling one another on the steps of the Elysée Palace? What's it all in aid of? They're merely trying to capture the expression on a face that's already been done to death by television cameramen.

Goodness knows what information a photo of this type can provide. No doubt all that frantic pushing and shoving should be seen more as the survival of a ritual and a token of respect for tradition. This cliquey trade has become more liberal, and a very good thing too. But although a new broom has swept the dust out of the corners, they've left the bronze group on the mantelpiece. Removing it would have been sheer sacrilege.

Legends and memories, dried flowers, a feeling of nostalgia on rainy days — they're all the respectable female companions of old age. But legends geared to the future and young people are filthy whores up to their necks in drug trafficking.

In press photos the myth of the hero is still valid.

This time the legend encourages young people to escape from the mediocrity of everyday life by following the same path as Tarzan, Zorro, Tintin, or some of the Formula One drivers. When they get to the end of it, the young hopefuls encounter an adventure in which they'll be able to show how generous, brave, and heroic they are. The path isn't without dangers, of course — this isn't a child's game — but oddly enough the memory of those who've been sacrificed, of those who failed to return, is so alluring it makes their heads

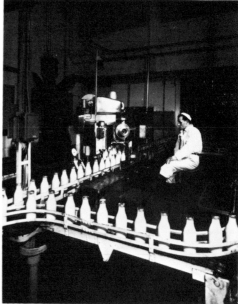

A milk bottling plant. The role of the operator here is solely that of overseer.

spin, sweeping away any lingering doubts about becoming patriotic young heroes with a camera. Now, my lad, you with the shiny new camera, before you make up your mind, make sure you realize there'll be no going back.

How can you expect to match the epic, spine-chilling tales? You'll never be able to find the same lyrical tone to describe the other alternative — staying with the others and finding thousands of things to gladden your heart on your own doorstep. If you're trying to tear someone away from a fanfare to adventure it isn't very clever to suggest a short solo on a penny whistle!

Nowadays you're thought incredibly ham-fisted if you talk about being patient. Yet it's the only way you can learn how to win luck over to your side — you'll never get anywhere without luck. Being patient isn't too high a price to pay for the joy of witnessing just for a second, in sheer amazement, a harmony you weren't expecting.

I can assure you it's a fairly rare luxury to be able to thrust under the noses of your contemporaries, who've been dazzled by moving pictures, one of these little gems that was just about to vanish into the dustbin of time.

When Jacques Prévert called Edouard Boubat a "peace correspondent" he was paying him a very fine compliment.

A Ball on a Pinball Table

Nowadays I've got more self-assurance and I go to Paris every day. But I can't shake off the feeling that I'm just a visitor. My suburban childhood clings to me like a leech. Paris was on the other side of the *fortifs,* the old fortifications running around the city. With my nose pressed to the windowpane I used to watch the yellow tram rumble past. It was the number 93 and its route was Arcueil–Châtelet. On the suburban part of the run it was on a single track, with passing tracks for when two trams crossed.

I was lucky enough to live opposite a set of points, so I could watch from my window as the conductor climbed down and tried to hook the trolley arm onto the other wire, hanging on to the end of the rope like a bell-ringer. He never managed it first go. If he was making a real mess of it the passengers would get off to call out advice to him, and it would end in a slanging match. Whatever happened there'd always be a splutter of blue sparks like fireworks — it was terrific. There was never a dull moment in my house, and sometimes we'd even take the tram ourselves. Close up, the conductor seemed much more commanding than when I peeped at him through the window. "How old's the lad, then?" And then he'd call out the names of the stops — "Peupliers . . . Rungis . . . Glacière . . ." — and we'd trundle on into the heart of Paris via the boulevard Saint-Michel and come to a halt behind the Châtelet theater on the railway track used at night by the Arpajonais, a suburban steam train.

But that, my dear young readers, we'll tell you about some other time. Now let's leave the 93 in the Transport Museum.

As I was saying, I'm not entitled to wear the "Parisian" label, though in fact I do know the city well because I've so often crisscrossed it on foot. Put it this way: I think of Paris as a kind of crazy-paving footpath, the sort that lets you cross a lawn by stepping from one paving stone to the next without ever touching the grass. I can go from Montrouge in the south to the porte de Clignancourt in the north following a sort of dotted line. Every few hundred yards I come across someone I know — a bistro owner, a cabinetmaker, a printer, a secondhand-book dealer, a painter, or just someone I once met in the street and ever since we've gone on writing to each other. It does slow me down a bit, but it's great fun.

I make a point of varying my itinerary so that I discover new actors and new scenery instead of automatically plunging straight back into already familiar delights.

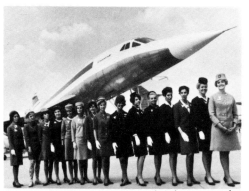

A range of uniforms on a conga of air hostesses, taken when Concorde was expected to achieve worldwide sales.

Wherever you go something's always just about to happen. All you have to do is wait. But you must look long and hard before the curtain deigns to rise. So I wait, and each time the same pompous refrain runs ironically through my head: "Paris is a theater in which you pay for your seat by frittering time away." And I'm still waiting.

Standing still when other people are rushing about in all directions all around you can give rise to misunderstandings, as I realized one day when I'd taken up my post and a stranger whispered in my ear: "You're in the know too; we're in the same racket!"

This way of going about things gives you a different outlook from other people's. Our contemporaries grope their way about in familiar surroundings, barely even giving a quick glance to make sure they don't trip up. And charter flights are full of people who need to travel thousands of miles before they'll condescend to glance about them. But if you're prepared to waste time instead of traveling all those miles you can reach the same happy state.

A little while ago, I regret to say, I realized that my method can go wrong. As I said earlier, I was always varying my route. Well one day, inevitably, I came across a whole block of brand-new concrete buildings. I waited, as I do everywhere. Nothing happened. Dammit, I wasn't going to take pictures of vertical vistas or try to create overelaborate effects. Okay, the people who lived there were obviously out during the day, so I decided I'd wait till the evening. But the lights went on and I still hadn't seen a soul. They'd slipped silently into the underground garages and been sucked up by the elevators to their televisions without ever being visible.

After the news a few dogs did come out to water the potted plants that passed for a garden, while their owners stayed close to the main doors, carelessly jangling their leads. Apart from that I didn't manage anything more remarkable than the biggest flop of my whole career.

The mood of boredom that pervades these tenant-storing silos isn't the same as in my suburb. It isn't gray at all. It's all decked out in garish colors, trying to hide its identity by putting on fancy dress. Every now and then they take on someone to liven up the place by dotting a few Breton pancake parlors or craft studios or fire-eaters around the edges, the idea being to add a touch of folksiness and raffish lunacy to it all. The developers have managed to do what the Germans never dared to do in 1944 — and without the din of explosives either.

First of all the plebs were asked if they would very kindly take their stink elsewhere. The whole operation was carried out very discreetly. I remember models being put on display at the Hôtel de Ville to show how the Les Halles district was going to be redeveloped. It all looked splendid. The public were allowed in and were asked to write down their suggestions in huge ledgers, with the assurance that they would be carefully examined and taken into account. Meanwhile rat catchers dressed in white were striding through Les Halles brandishing buckets of rat poison and giving the Parisians the impression they'd narrowly escaped going down with cholera.

As a result there's no one left to stroll along the streets, the car drivers glare furiously out of their aquariums, and the only people you come across on the pavements are on their way to or from a railway or metro station, always late and often in an aggressive mood. Long after the bulldozers stopped tormenting the city the demolition is still going on, with buildings coming crashing down and leaving the streets full of broken glass, so that no one would want to hang about there.

Mind you, it would need more than that to put me off — I shall always be the last person left sauntering in the street. The word "saunter" has got a delightfully old-fashioned ring about it somehow. It's as if you were saying: "My dear fellow, do have a spot of Madeira before setting off to the cinematograph in your open tourer!"

But old-fashioned or not, if there's just one saunterer left, it's bound to be

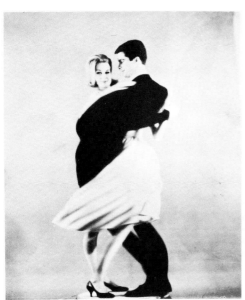
A photographic image made by the same modified Speedgraphic.

me. Nothing can stop me going to the Pont Alexandre III, where the bronze seems to be forever blowing bubbles with its merry-go-round of plump ladies and chubby children — what a splendid bit of *fin-de-siècle* fantasy. And over there in the distance is the proud geometry of the Hôtel des Invalides, accentuated by a row of rusty cannons and topped by the famous dome beneath which Napoleon was eventually pinned down under tons of red porphyry.

From there I shall follow my usual practice and move on to the quai du Louvre, and lean on the parapet opposite Wyers, a shop selling fishing tackle. From there you can enjoy a giant-screen presentation of Paris spread out horizontally before you — the Pont-Neuf on the left, with Henri IV perched high up on his horse looking across at the two Louis XIII houses in the middle of the bridge and rightly proud of the building talents of his offspring. Opposite, floating on the surface of the river, is the jardin du Vert-Galant, with its hairy, bearded crew strumming away on their guitars. A glance to the left and there's the Pont des Arts, late lamented (but soon-to-be-resuscitated) museum of pavement art. In the distance a midget Eiffel Tower asks to be remembered to you.

I'll just smoke one cigarette and then I'll be off to the lock on the quai de la Rapée to board a barge on its way up to La Villette, so I can check whether the ventilation shafts in the tunnel really do let pillars of sunlight filter through. I'll stop off at the lock by the Hôtel du Nord — bags of atmosphere — and then hesitate before deciding whether to aim for the bakers in the rue Sainte-Marthe or the flight of steps in the passage Julien Lacroix. In the end I'll choose Ménilmontant. Sad to say the little turret in the rue Vilin has vanished, along with the house where Madame Rayda the fortune-teller used to live and the bent lamppost bearing the number 3593.

Even up on the heights the developers have struck. With them about there's no danger of Paris becoming a museum city, rather like those bunches of artificial flowers that will never have the ephemeral charm of real flowers. I personally feel that I'm biodegradable and I prefer to make for the suburbs that are threatened with demolition. I like places where all the houses look different. I only feel at home in the sort of streets where you come across an old-age pensioner with a little white dog, a flower lady, a kid on roller skates, and a fat man all at the same time.

If you're going to work in a life teeming with people you must have a few rock-hard principles to anchor you and you mustn't dissipate your efforts. So I decided to stick to ordinary, everyday life for my source material and steer clear of picturesque effects. When I had to choose between a member of some lunatic sect and a French polisher, I'd choose the French polisher. His family would subsequently take me under their wing, and so would his pals in his workshop and his favorite bistro. It all happened very naturally and smoothly. This program took up all my spare time.

Once again I had to come to the following conclusion: as soon as I try to adopt a logical attitude, as soon as my timetable starts looking humdrum, Someone-Up-There sends me somebody to mix it all up again and make my efforts even more chancy than before. With the next person who came along I was never in any danger of sinking into an attitude of routine indifference.

I got to know Robert Giraud at Romi's, an art gallery in the rue de Seine, where he was waiting patiently for a customer to turn up. In the daytime he was as somnolent as a cat. In fact he was like a cat in lots of ways, though he didn't make you think of a pretty little pussycat when you saw him creeping furtively along, hugging the walls like a tomcat on crêpe soles as he set off for his nocturnal assignations. Sometimes, and this seemed to me a pity, he'd fight like a snarling cat, becoming suddenly vicious. Usually he'd be lying in wait, propped up on a bar counter somewhere, for hours at a time. And someone would turn up — there was always a nocturnal down-and-out who'd come and share a drink with him.

He'd regale us with the story of these encounters at a café called Fraysse. "Us" was a classful of students busy studying Beaujolais (I'd managed to pass the entrance exam). We had to use plenty of friendly persuasion to get him to make up his mind to write a book. Jacques Prévert, who was very taken with the manuscript as soon as he saw it, suggested the title *Le vin des rues*. It's a sort of herbal or specimen book 234 pages long in which love's ministering angels and their pimps rub shoulders with tramps and beggars (full of little schemes for making sure that this threatened species survives), small-time swindlers and also, not a pretty sight at all, a few highly immoral gangsters. In other words, all those people who surface when law-abiding citizens are abed.

All you had to do was "follow the guide." There he was, beaming with pleasure and clearly in his element among all this riffraff. But his delight was slightly marred by one regret — in a bistro in Les Halles he'd caught sight of a solitary figure with a death's-head tattooed on his face. He'd knocked back his drink and then disappeared into the night, and although friend Giraud had looked for him all over the place, he'd never seen him again. You couldn't find a better example of an out-and-out rebel. Would Giraud ever manage to scent him out? I haven't heard yet, but he dragged me with him into the world of tattooing.

"Any tattooed person here who wants to earn himself two hundred francs?" We were in a bistro on the corner of the rue Dante and the rue Laplace called Aux Cloches de Notre Dame (it isn't there anymore). They served rough red wine in beer tankards and woe betide you if you took your eye off your tankard for a second — someone would probably empty it for you. Not that it mattered, the wine wasn't any good. I prefer something less acid.

The clientele was made up of tramps and rag-and-bone men, and first-class specimens they were too. If they were tattooed on the arm or chest there was no problem — the others would just move over a bit to let you see. But for people like Marceau it was more awkward, because his tattoos were spread all over his person and so encrusted with dirt he had to clean up a bit first. This gave us a chance to make the acquaintance of Melanie in their digs, where she was busy brewing up red herrings over a charcoal fire. The walls were festooned with prints from the magazine *Adam* and she was busy wailing: "I wasn't expecting visitors. We're only poor working people, I'd have tidied up if I'd known. You must come and eat one lunchtime. It won't be anything fancy. There'll be four of us so bring eight liters of wine."

But the *pièce de résistance* was Richardot, who was covered in tattoos from head to foot, like a walking roll of printed fabric. I know works of art aren't much concerned with logic, but I've often wondered how President Carnot had managed to inveigle himself into those twirling patterns of girls and animals and flowers. The only blank space was an upside-down triangle leaving his eyes, nose, and mouth free. Beneath his underpants, needless to say, there was a picture of Hell.

The children hid under the bed when he came to our house.

Richardot came to a bad end. He used to display himself in bistros, offering to undo his dressing gown in return for a few coins. One fellow sniggered. Richardot wasn't used to such disrespect. "Come outside and show what you're made of." The iconoclast went out first — a little technical error. Richardot died in prison.

Just one more thing: in the space for "distinguishing marks" on his identity card some civil servant had written: "None."

The files in newspaper and press agency offices always include a box labeled "Freaks and oddities." In this all-purpose file you'll find tattooed people rubbing shoulders with collectors, cranks with Utopian dreamers. In fact the very people who are appalled at the idea of being pigeonholed.

But oddly enough all these dreamers and idealists do have one thing in common — they've been woken from their sleep by a voice, perhaps the

A couple and a coffee grinder. Proposition No. 23: spontaneous mystification.

A couple and a coffee grinder. Proposition No. 11: amazement.

Virgin Mary or one of their ancestors. Anyway, it's always been a voice they couldn't ignore, no two ways about it, and they've leaped out of bed.

Frédéric Séron, like all the others, hadn't offered any resistance when he heard a voice from beyond. And there to prove it was a whole zoo full of cement animals who'd taken over his garden in Pressoir-Prompt beside the Nationale 7 road.

I've never counted them, but if you include the doves there must have been a good fifty of them. And sealed up inside each one was a steel cylinder containing his visiting card, a copy of the local paper, and sometimes a photo of some official or other. The animals were his personal pyramid. They represented his determination not to disappear completely. "They'll find it all a thousand years after my death. I'm not afraid of dying, but believe it or not, when I put the eyes in they seem so alive I have to go out into the garden."

Cheers! Frédéric Séron made his own wine, which was very rough and luridly colored, but natural tasting. The countdown has started now. All I've got left of him is a picture he once gave me. It's painted in light cement and depicts an elephant hunt.

Tourist buses spill out their passengers in front of the *"palais du facteur Cheval"* and the high priests of culture travel from Chartres and start mouthing their claptrap, smiling condescendingly all the time, with a quick nod to *art brut* here and another to "our cultural heritage" there as they stand before Raymond Isidore's mosaics made with bits of broken plates. Museum keepers tend to give sidelong glances at works of art that were produced in spite of the mocking laughter of the neighbors.

They haven't got around to talking about Gilbert Frugier on the radio yet. I wonder why. Perhaps he's too much of a one-of. They'd have to start a new file with some highfalutin label such as "collector-magicians." But he wasn't inspired by an urge to collect things so much as by an urge to transform them.

I think I understand his method: you take an object that's no longer fulfilling the function it was designed for and then, having freed it from its functionalism (like someone who's been pensioned off and devotes himself to some skill or art), you turn it into an ornament or a piece of decoration. His house was like a Palace of a Thousand and One Waifs and Strays, with its pillars made from stovepipes and its chandeliers gleaming with old light bulbs.

I stayed late into the night and I could hardly keep awake. His treasures filled two whole floors and he showed no sign of flagging. He'd suddenly emerge dressed as the Sun King with a wig made from old corks, or disappear behind a screen made of calendars, only to pop up again disguised as a knight with a breastplate made from beer bottle tops. The knight would soon give way to the great god Pan with horns made of the rubber teats used to feed calves.

As far as I could make out the neighbors hadn't been too keen on him ever since the day he took the shutters down and replaced them with panels depicting simpering Assyrian kings — he'd rescued them from among the stage sets used in the theater in Limoges. But he was far too busy ferreting about in dustbins to worry about his neighbors' obsessions — he never gave them so much as a glance.

If you're an armchair traveler the first thing you have to do is get the walls to vanish. Gilbert Frugier's method was to cover them with objects. There are other methods, of course. Personally I'm not very musical, but I've been told that music gives good results.

But let's steer clear of sordid solutions and artificial paradises and stick to noble materials. It seems to me that a veil of shadow can make a very effective dust sheet.

You must start by taming light, which is a relatively simple matter once the sun's gone down. So at night you stand a better chance of meeting the people Jacques Yonnet called the "watchmakers who put the clock back."

The three fellow photographers I met after sunset don't come into the category of people who love the half-dark. They're sports reporters and they're more the hearty, outdoor type.

One evening we happened to be together in a spa town, where we were covering one of the stages of a cycle race. The town seemed to have turned to stone with its decorative metalwork painted white and its lampposts with white globes. At the end of dinner — we hadn't touched a drop of mineral water — we all agreed that it was bad for you to go straight to bed after a meal, as any doctor will tell you. So we set off into the night, walking slowly, the way people always do in spa towns, going nowhere in particular.

Well, we weren't exactly going nowhere. We felt we were bound to come across a bistro on our travels, and sure enough we did, though actually it was a bar. Pseudo-luxury with the inevitable American soldier getting thoroughly sloshed and offering around a packet of Philip Morris. The barmaid swaying her hips with that sulky, sullen look that was the last word in sex appeal at the time. Another girl popping her head around the door every five minutes: "Hasn't Marcel come?" All these unimportant details produced a whiff of the clandestine atmosphere you find in gambling dens or brothels, and the conversation turned quite naturally to the demise of the brothel.

It was all very gloomy: "Ah yes, the Panier Fleuri." "Didn't you ever go to the As de Coeur or the Chasseur Magique with that girl from Martinique dressed up in Alsatian costume?" A few fruit liqueurs, *framboise, prunelle,* the sort of thing that's still with you the morning after, kept the mood of nostalgia going. Closing down the brothels is of course ludicrous in the land of Descartes, but let's forget that for a moment — the worst thing surely is that we'll never again enjoy that blissful feeling of being a big fat baby gurgling with glee while a firm but gentle hand sprinkles us with talc.

A newcomer had joined us at our wailing wall; I hadn't noticed him join our group. He was very distinguished-looking, not quite a grand old man yet, but he soon would be. He didn't want to be indiscreet, but you'll be amused to hear that he said: "I've got my car. It'll only take five minutes."

We drove out of the town to a smart residential area with detached houses, gravel drives, steps leading up to the front door.

"I'll lead the way. It's on the first floor."

A short steep staircase.

"Do come in."

At first we couldn't make out anything much. Then we goggled in amazement. It was a real shock — black stockings, wasp-waisters, garters. There were two of them standing up and apparently deep in conversation, while the rest of the inmates were scattered about over three divans, with a few spaces left for guests to sit down. One woman was swinging one of her legs; another's chest was heaving, so she was breathing — I almost said "she was *still* breathing"!

It was like a weird hallucination, and a trifle dusty too. We felt somehow uneasy. Our new friend was beaming: "Do please sit down, I'll put on some background music." But with the sighs of the girls as well it was really unbearable.

Our colleague Louis, known as Loulou, managed to get out what we all wanted to say: "How delightful. But I'm afraid we must be getting back now. We're off at seven in the morning. We're awfully sorry. It really was delightful."

He'd done his best. No one uttered a word as we drove back.

"What are your deep-seated motivations?" I've often been asked that. I'm not

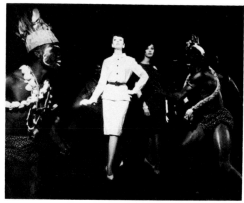

For Vogue. *Suit in fine cotton with a starched linen collar, surrounded quite naturally by Ivory Coast dancers.*

taken in by the intellectual-sounding phrase though; what they mean is: "How do you account for your wretched mania for taking photos off your own bat, without a commission?"

What a silly question — I haven't got a rational motive, it's more that I feel an irresistible urge to share with others the delight I've experienced through my eyes. It's purely instinctive. But I keep all that to myself and as I'm a very polite person I answer their aggressive question with a fine-sounding flourish: "I'm determined not to disappear." This little piece of repartee will spike my inquisitor's guns for a while, and as a matter of fact there is a grain of truth in it.

Disappearing as in the movies, in a fade-out at the end of a film, is more or less acceptable, but a sudden disappearance — bang! just like that — is another matter. I simply can't imagine it. I find the idea of seeing the captain's cap floating for a moment or two after the ship's gone down very reassuring.

If they'd put the same question about motivation and all that to all the thrifty collectors and all the builders of castles in the air I've come across, I bet they'd have given similar replies. I sought them out because I wanted to see how they managed to put the clock out of order and slow down time.

There was just one time when I got there too late. There was nothing left but a battlefield — the house had been gutted, the statues decapitated and mutilated, lying pathetically on the ground. The kids of Attigny hadn't waited long after Camille Renault's death. They'd acted like a flight of locusts. And by speeding up the natural process of erosion they too had fiddled with the clock.

And how cruelly — that poor chap who'd gone to so much trouble to drape his characters, adding a piece of jewelry here, another there, always so finicky. In the midst of all that carnage I felt again the same uneasiness as I'd felt one day during the war when I discovered a doll among the rubble on a bomb site. Brr . . . The anguish of realizing that the work you leave behind you when you die can't be guaranteed to act as a brake on time may well discourage a reasoning person and undermine his morale for good. In my own case, as I've said, it's merely a question of instinct.

I'm always drawn toward light. A lamp lights up and I rush toward it like a mad thing. It's a phenomenon they call "phototropism" when they're talking about insects.

The snow covered over two piles of gravel by the civil engineering department on the route from Laffrey to Saint-Jean-de-Vaux.

Of Sledgehammers and Nuts

I'm not a collector at heart. I'm never tormented by the longing to possess things. I'm quite happy with my pictures. I've been cohabiting with them for years now and we know each other inside out, so I feel I'm entitled to say that pictures have a life and a character of their own. Maybe they're like plants — they won't really flourish unless you talk to them.

I haven't gone that far — not yet anyway. Lots of them behave like good little girls and give me a nice smile whenever I walk past, but others are real bitches and never miss any opportunity to ruin my life. I handle them with kid gloves.

Let's keep our voices down. In the loggia, above the table where I'm writing, are three fat files. They've got fatter and fatter over the years and it may well be that one day, if I add just one more photo, if one of my naughty lodgers adds her weight to the load, the beams will collapse with a loud crash. But let's dismiss all thought of such an unhappy ending. On a more prosaic note I'm always finding myself hunting feverishly through the files with someone waiting on the other end of the phone. "Just hang on a moment!" I say, rather proud of my efficient filing system.

But as I'm riffling through, one picture stops me in my tracks. It's just as if I'd got tangled up in a bramble bush and I completely lose the thread of what

I'm looking for. By the time I've extricated myself the person on the other end has hung up, in a fury no doubt. They're a funny lot; they expect me to be constantly at their beck and call and don't realize that over the years some pictures take on a sort of hypnotic power, whereas others turn into aging coquettes, so dreadfully old-fashioned you feel embarrassed at meeting them again.

"However could I have taken that?" you say to yourself. And yet I was reasonably pleased with myself at the time, and in fact it is quite clever, rather neatly done, really very ingenious. Yes, but since then other younger and more obviously clever photos have come on the scene, and their short-lived triumph banished the other pictures to the attic, since they too were only valid because of a series of illusory trick effects. I'll make do with this explanation — no point in wasting any more time on mediocrity — but I can't explain away quite so casually the fact that my photo companions seem to have found a recipe for the elixir of life.

In fact there isn't any recipe — that would be too easy — but all these images that are growing old so gracefully were taken instinctively. I put all my trust in intuition, which contributes so much more than rational thought. This is a commendable approach, because you need courage to be stupid — it's so rare these days when there are so many intelligent people all over the place who've stopped looking because they're so knowledgeable. Yet that little extra something supplied by the model is precisely a "look," like a legacy handed down to you from the distant past. It shoots straight along the optical axis and bores right through the photographer, the celluloid, the paper, and the viewer, like a laser beam scorching everything in its path, including, and a very good thing too, your critical faculties.

Yes, I know, you're supposed to tell your sitter not to look at the camera. It's an order, because the huntsman mustn't be suspected of being in league with his prey.

And what a superb huntsman he is, with a feather jauntily stuck in his hat — but his head is quite empty. Making people look away means that the picture loses most of its mysterious power. The way I see it, you mustn't be afraid of coming up with things for which there's no explanation, like the village idiot coming back with some unknown bird in his cap.

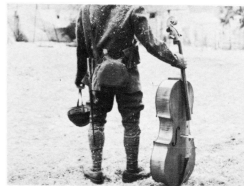

An image taken from a project still in hand after twenty years. It is for an illustrated book of memoirs of the cellist Maurice Baquet, to be entitled "It Tastes Like Veal."

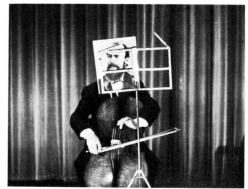

The classical score. Another page destined for the ever-unfinished book "It Tastes Like Veal."

"How odd," I said, "how very strange." But I've stopped joking about that sort of thing ever since I met Pascal Fortuny. He lived in a modest little house in Montmorency. The furnishings inside showed no signs, to put it mildly, of idle frills. I took the portrait of a very elderly bearded gentleman, almost blind and wrapped in a dressing gown, with the beret worn by the mountain light infantry regiments perched on his head.

His attitude was kindly but aloof, and not a word was said — we didn't have much to say to each other of course. When I went to say goodbye he suddenly became affectionate and took my hand in his, which were long and wizened. I remember he had a ring with a huge stone — and then a sudden blank. I felt literally worn out, bled white, drained, incapable of driving my car.

Is there anyone in the house who can tell me in words of one syllable what happened that day? No, please ask those gentlemen over there to sit down. I didn't ask for a couple of male nurses. A psychiatrist perhaps, or anyway someone who'll speak clearly and simply. It's probably much the same as in photography — words make a pleasant sound but they don't contribute anything. You'll feel less awkward if you keep quiet and just show your pictures.

Don't be led astray by my reference to the magic power of images and start getting your pins out. That's not what I mean at all. The magic I'm referring to has got nothing to do with The Great Mephisto (or The Little Mephisto for that matter). It can take a very pleasant form and pop up when you're least expecting it.

For instance it can appear in the shape of a letter. A new friend whom you'll never meet has seen a photograph of yours in his local paper out there in the back of beyond and felt an irresistible urge to write to you. A case like that must involve a phenomenon of harmonic vibration transmitted over long distances without all those coils of wire you normally need for this type of communication.

Then again I think I've seen magic on the ceiling of a truck driver's cab — when I woke up in the early hours on the Nationale 10 road near Couhé-Veyrac to the welcoming smiles of a dozen Marilyn Monroe blondes.

You must just let yourself go, and soak up the enchantment so that it becomes a familiar atmosphere. Far less research has been put into this than into the hunt for new Mannerisms, in which you can so easily fritter away your youth. Leave all that to the oldsters — they've got so few pleasures left.

I once crossed over the Pont-Neuf with a so-called cultured man. Over to the west a sunbeam lit up the Seine in a magnificent blaze of light. "Oh, look!" Then he grunted: "Pure Marquet!" As soon as a chink appears and he catches a glimpse of something dazzlingly unexpected, what does he do? He plugs it with words. That's all it does to him. The data have been received inside his head and promptly filed away. No emotion, for heaven's sake — that would mess up his tidy system and he'd have to sort it all out again. And anyway a bridge really isn't the place to admire things, that's what museums are for (just as other people might say, when they see a pair of lovers kissing in the street, "That's what hotels are for!").

I let him set off toward the Institut de France, bowed down beneath the weight of his erudition. Fellows like him are dangerous, they're so sure of themselves. If you gave them half a chance they'd stuff you while you were still alive. They're the sort of people who rummage about in your innards, like forensic pathologists — and they've never helped anyone to stay alive.

Well, I've had my say. Every now and then you have to knock the odd idol off its perch, shoot down the odd sacred cow, then creep off on tiptoe, feeling much better and ready to start again.

Some days the mere fact of seeing feels like perfect happiness. You feel as if you're floating along. The cops stop the traffic to let you through and you feel so rich you long to share your jubilation with others — you've got more than enough for yourself after all. The memory of such moments is my most precious possession. Maybe because there've been so few of them.

A hundredth of a second here, a hundredth of a second there — even if you put them end to end they still only add up to one, two, perhaps three seconds snatched from eternity.

Robert Doisneau

Biographical Notes

1912 Robert Doisneau born in Gentilly in the Val-de-Marne just outside Paris

1926 passes the entrance exam for the Ecole Estienne in Paris, where he works in the engraving department

1929 awarded engraving diploma

1930 first attempts at lettering and advertising photographs

1931 becomes André Vigneau's cameraman

1932 sells his first story to *Excelsior* magazine

1934 joins the Renault factory at Billancourt on the outskirts of Paris as industrial photographer

1939 fired from Renault for being consistently late; meets Charles Rado, who started the Rapho photo agency, and starts taking a few photographs in the street; when call-up comes, dons the uniform of the light infantry

1942 meets Maximilien Vox, who commissions him to illustrate a book called *Les nouveaux destins de l'intelligence française*

1945 joins the Alliance Photo press agency

1946 meets Raymond Grosset and returns to Rapho, for whom he has been working ever since; also meets the poet Blaise Cendrars and Jacques Prévert and his brother Pierre; starts working with Pierre Betz, the publisher of the literary magazine *Le Point*

1947 wins the Prix Kodak

1949 signs a contract with *Vogue*

1952 decides not to renew contract with *Vogue;* works with Robert Giraud on the theme "Black stars — night people"; starts work, with the cellist Maurice Baquet, on a "photo-musical symphony" called *Violoncelle-slalom*, which is still unfinished

1956 Albert Plécy presents him with the Prix Niepce

1960 is sent by mistake to Palm Springs, California, to do a story on golf

1968 does a story on fifty years of Soviet achievements for the newspaper *La Vie ouvrière*

1973 makes a short film with François Porcile called *Le Paris de Robert Doisneau*

1978 takes part in Fernand Moscowicsz's film *Trois jours, trois photographes* with Jeanloup Sieff and Bruno Barbey

One-Man Shows

1951 La Fontaine des quatre saisons, Paris: *Le monde des spectacles*

1960 Museum of Modern Art, Chicago

1968 Bibliothèque Nationale, Paris

1972 George Eastman House, Rochester, New York

1974 Galerie municipale du Château d'Eau, Toulouse

 Vieille Charité, Marseilles

1974–5 Witkin Gallery, New York

 Photogalerie Georges Bardawil, Paris

1975 La Galerie et Fils, Brussels

 Musée des Arts décoratifs, Nantes

 Musée Réattu, Arles

1976 Photo Art Basel, Basle

 Hôtel de Ville, Dieppe

1978 Galerie Agathe Gaillard, Paris

 Witkin Gallery, New York

 Musée Nicéphore Niepce, Châlon-sur-Saône

1979 Musée Eugène Boudin, Honfleur

 Musée d'Art moderne, Paris: *Les passants qui passent*

Group Shows

1947 Bibliothèque Nationale, Paris

1951 Museum of Modern Art, New York, with Brassaï, Willy Ronis, Izis

1965 Musée des Arts décoratifs, Paris: *Six photographes et Paris*, with Daniel Frasnay, Jean Lattès, Janine Niepce, Roger Pic

1968 Musée Cantini: *L'oeil objectif* (The Objective Eye), with Denis Brihat, Lucien Clergue, and Jean-Pierre Sudre

1972 French Embassy, Moscow, with Edouard Boubat, Brassaï, Henri Cartier-Bresson, Izis, and Ronis

1975 Bibliothèque historique de la Ville de Paris: *Le mobilier urbain* (Street Furniture)

1977 Centre Georges Pompidou, Paris: *Six photographes en quête de banlieue* (Six Photographers Looking for Suburbia), with Guy Le Querrec, Carlos Freire, Claude Raimond-Dityvon, Bernard Descamps, and Jean Lattès

List of Plates

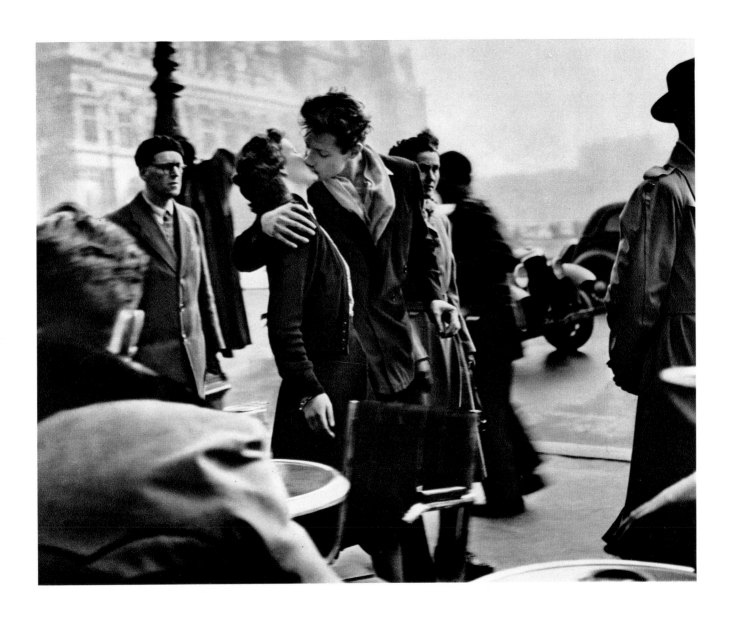

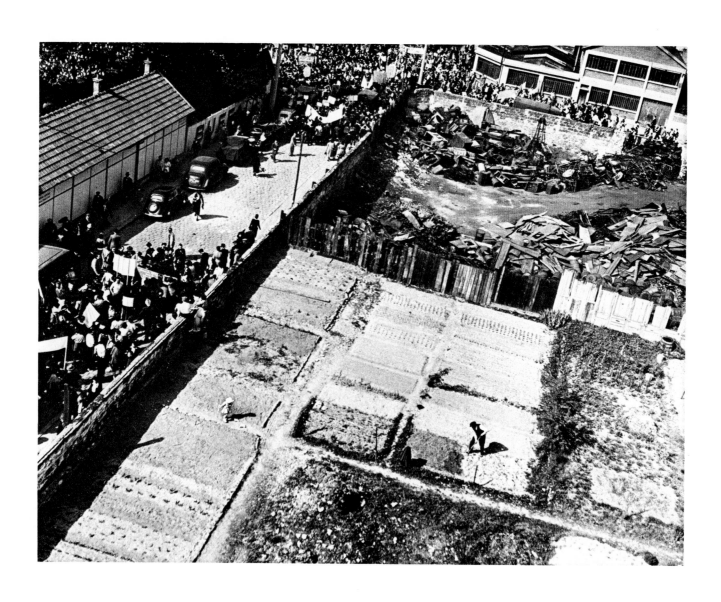

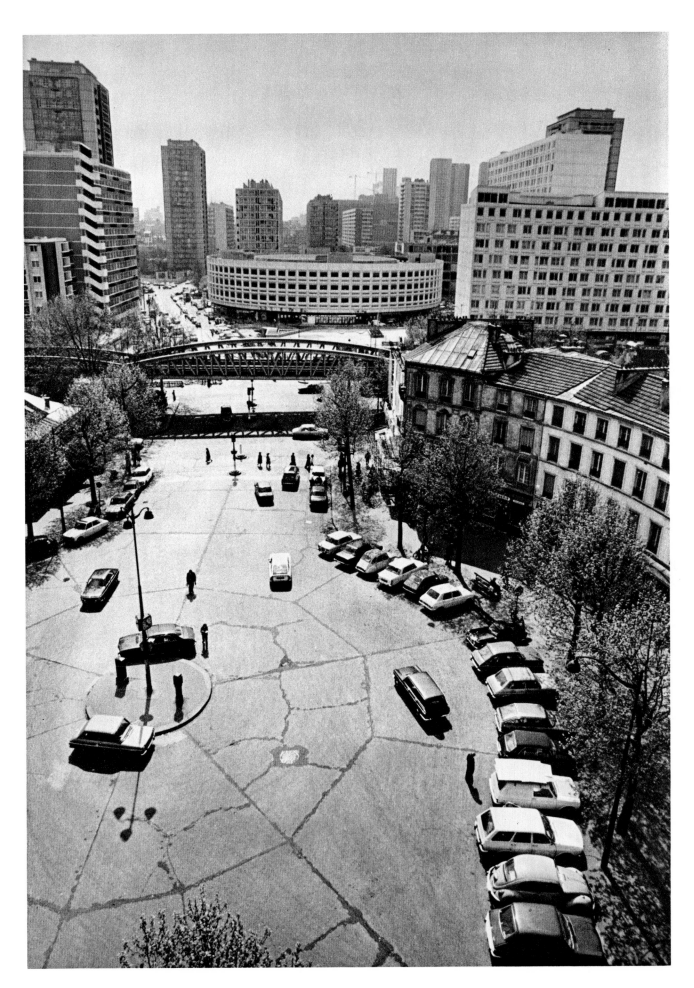

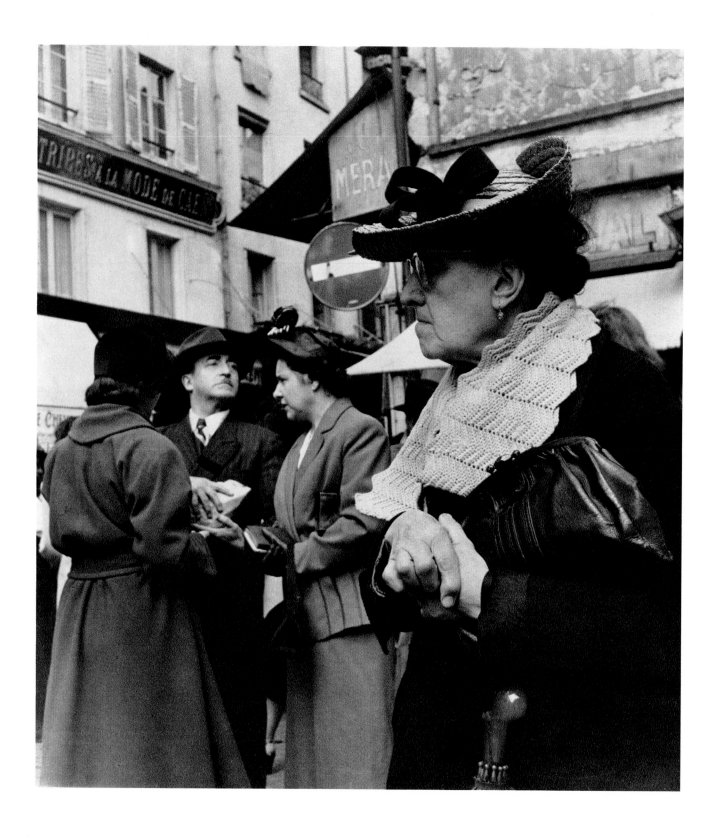

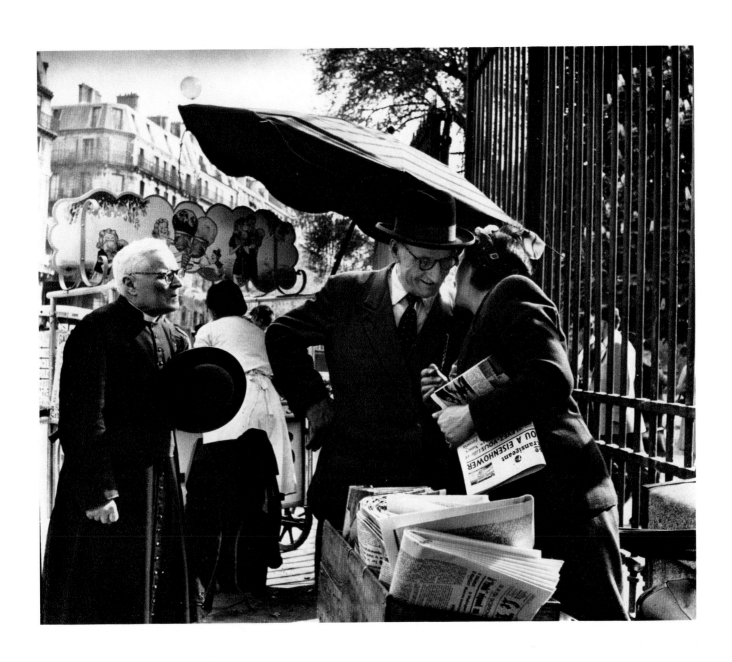

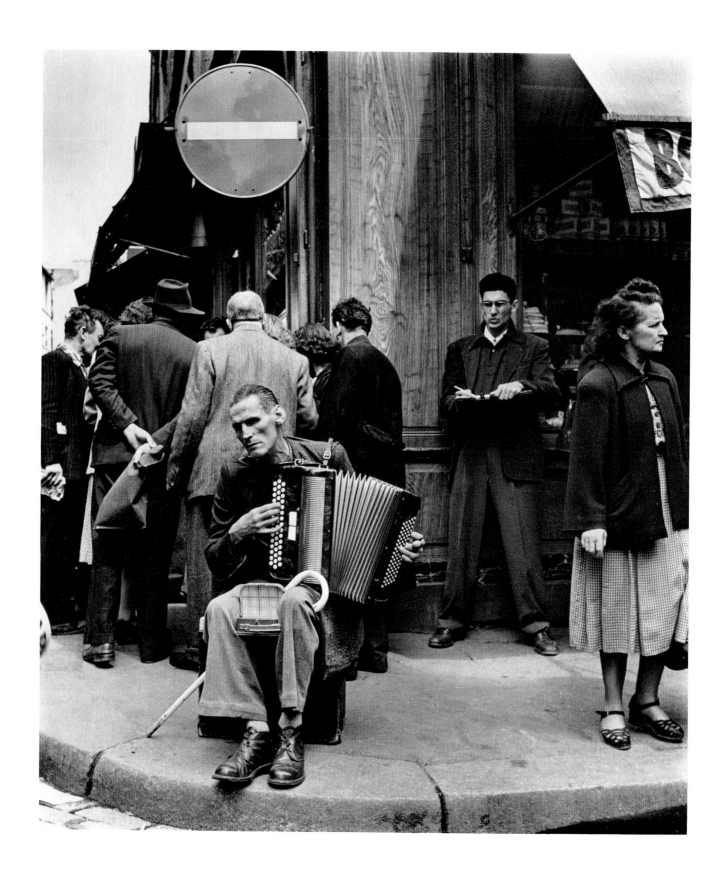

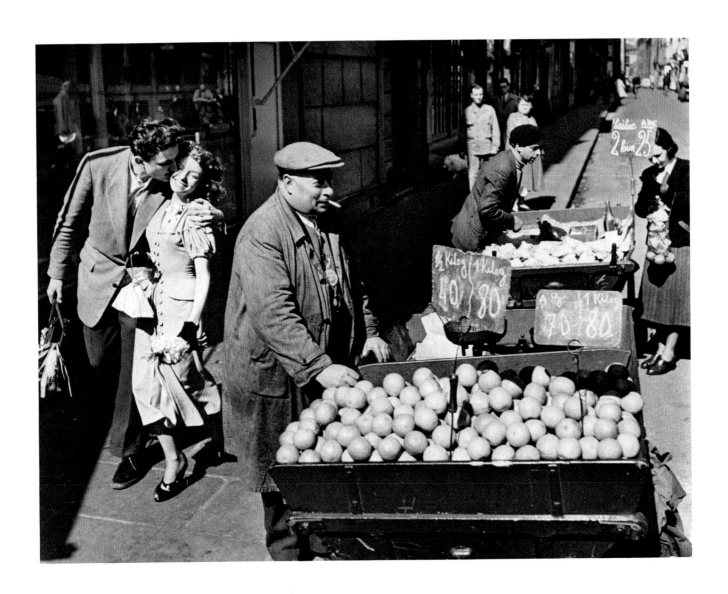

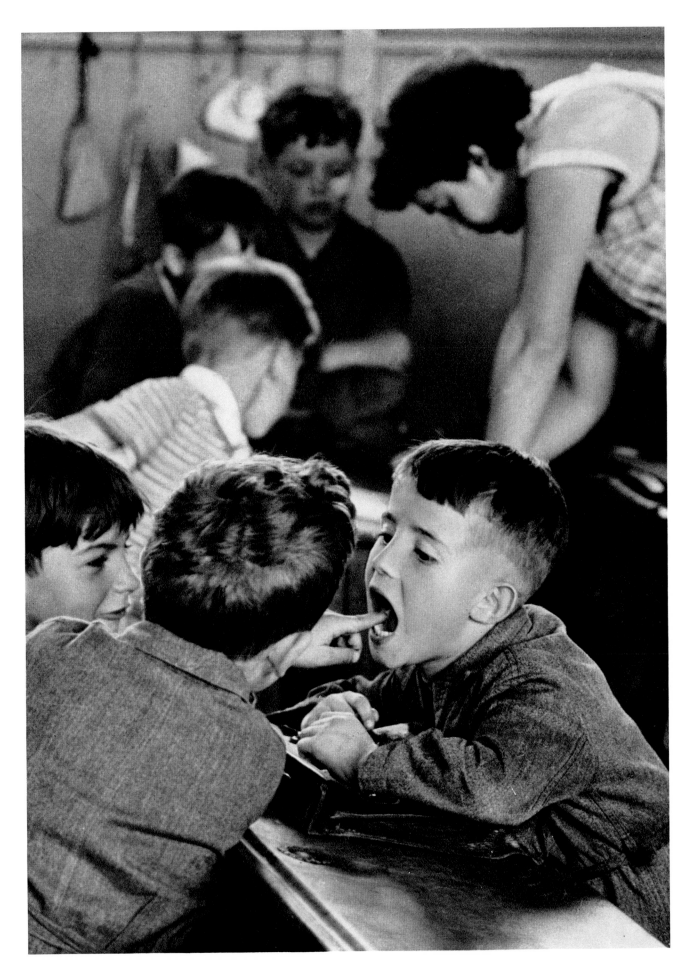

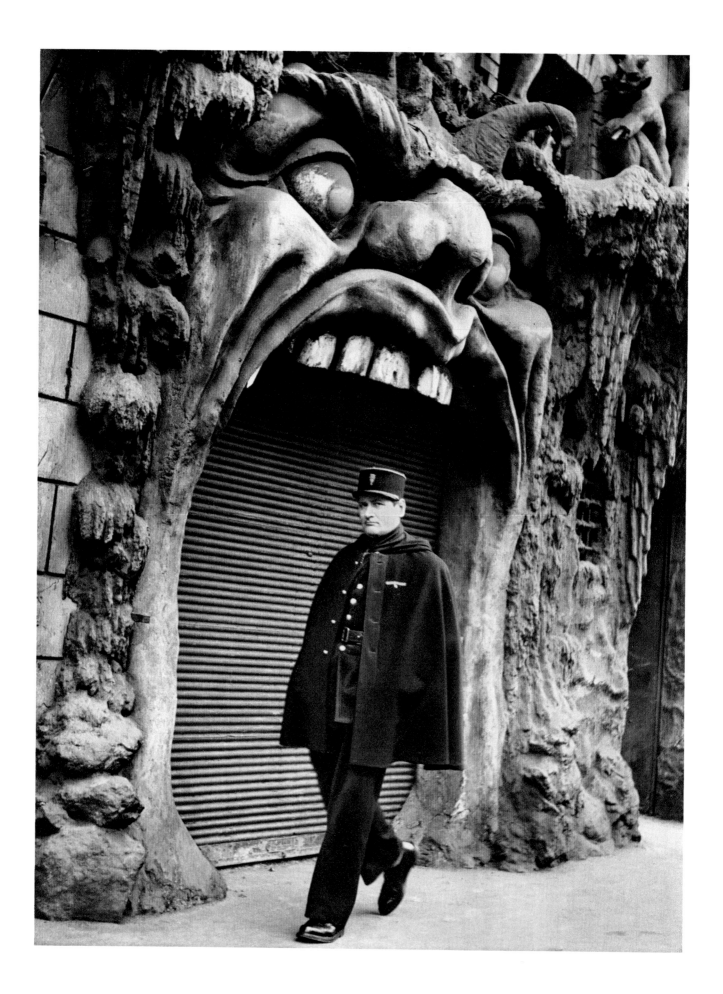

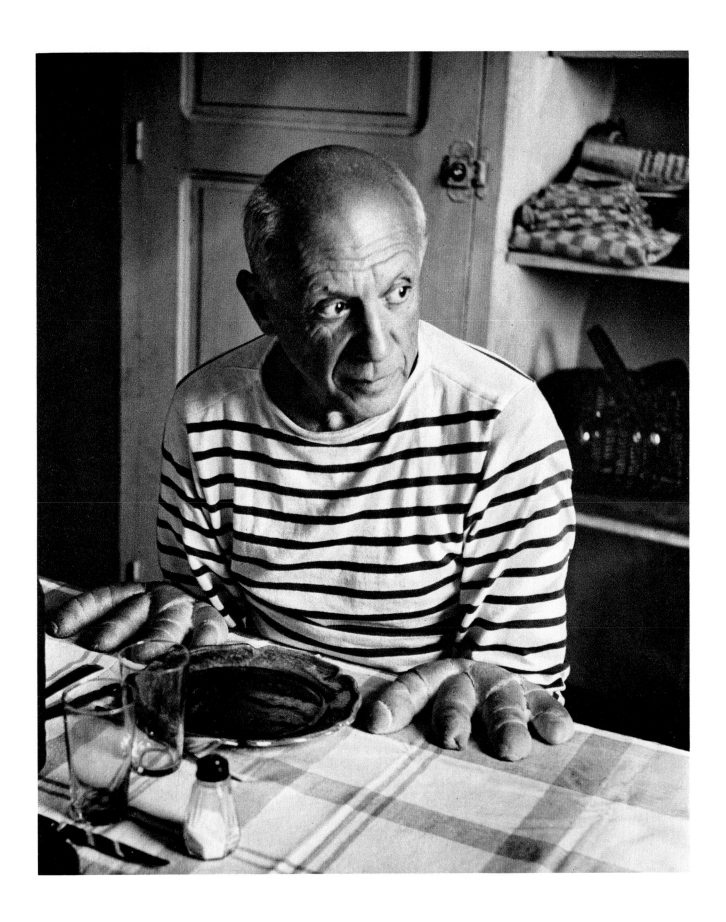

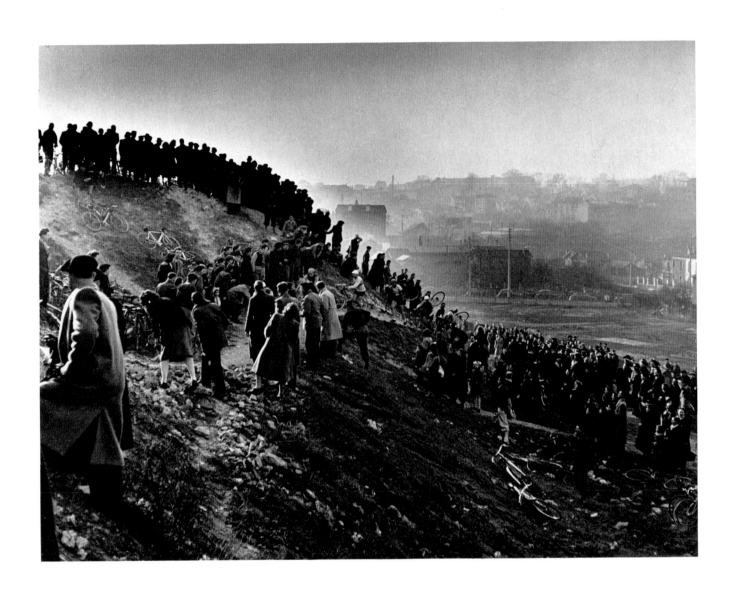

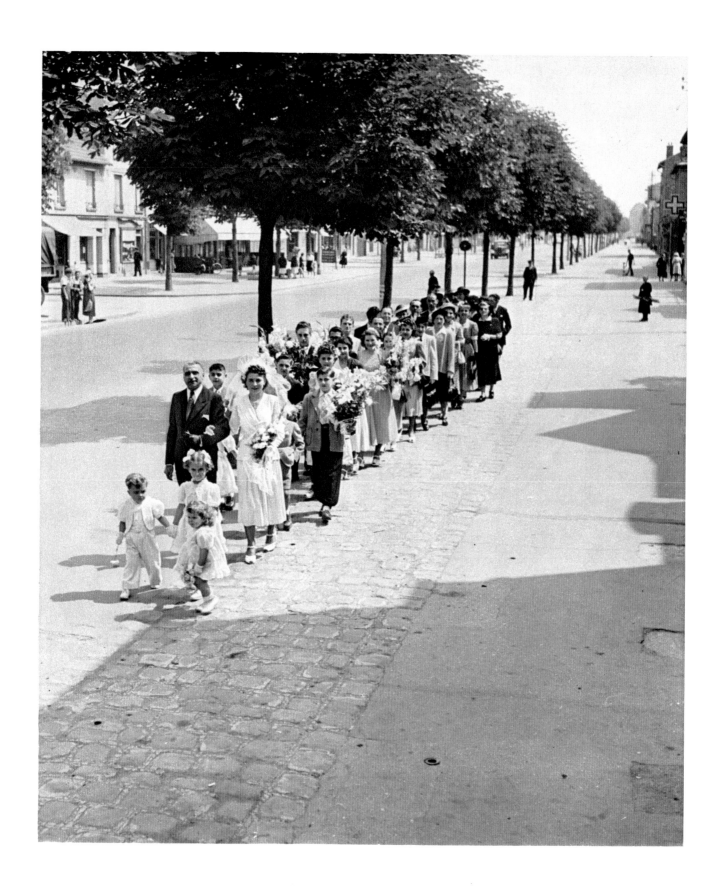

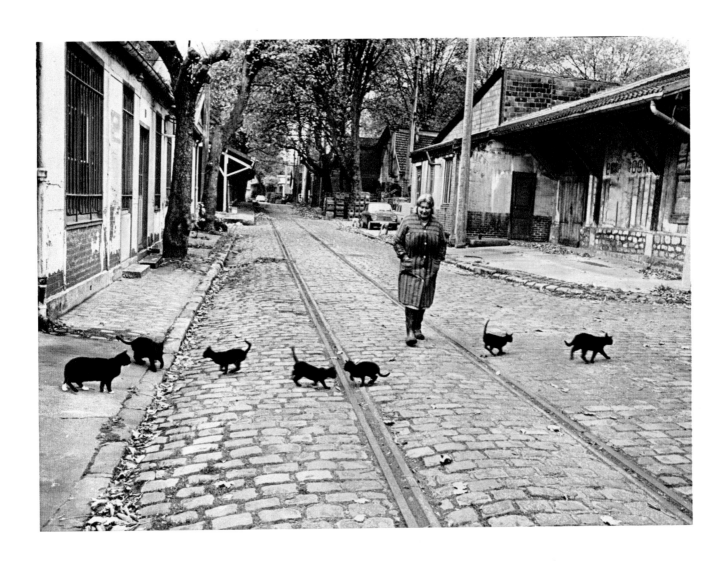

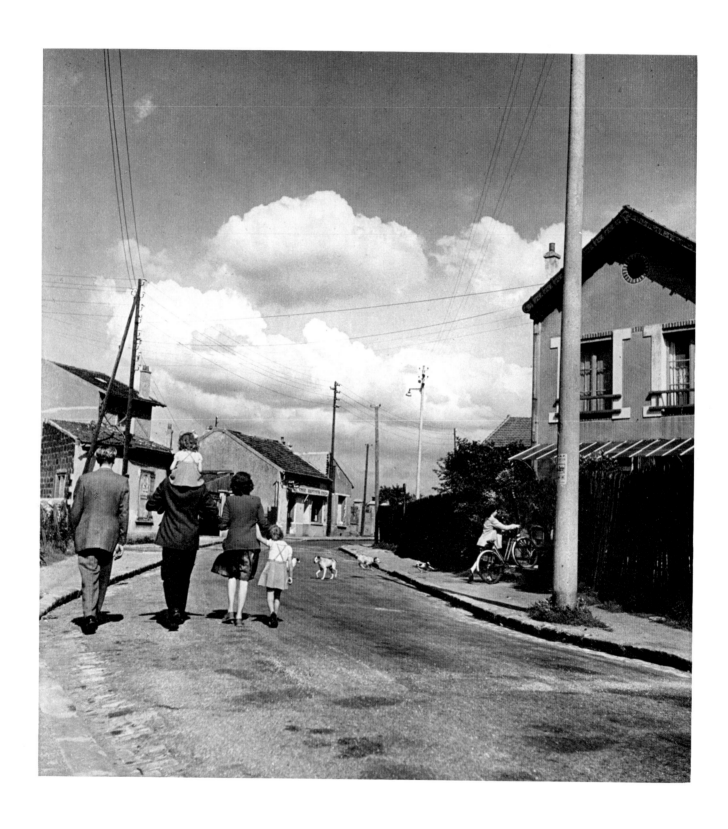

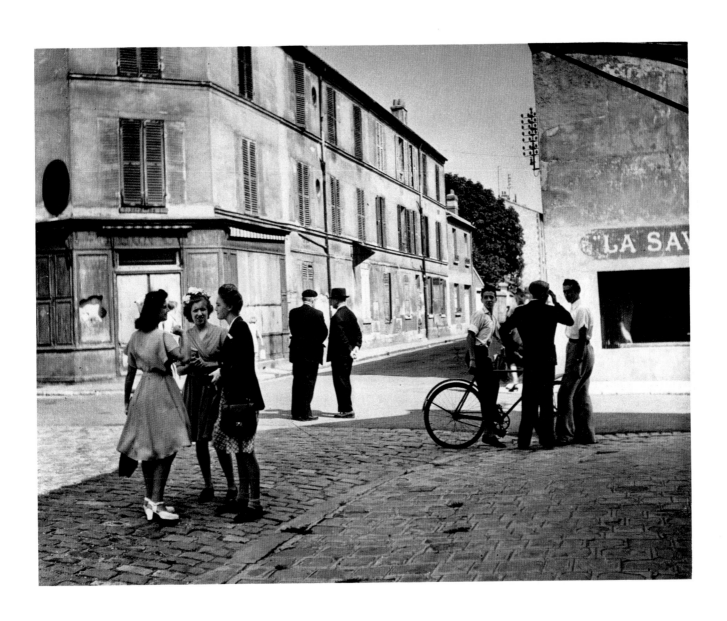

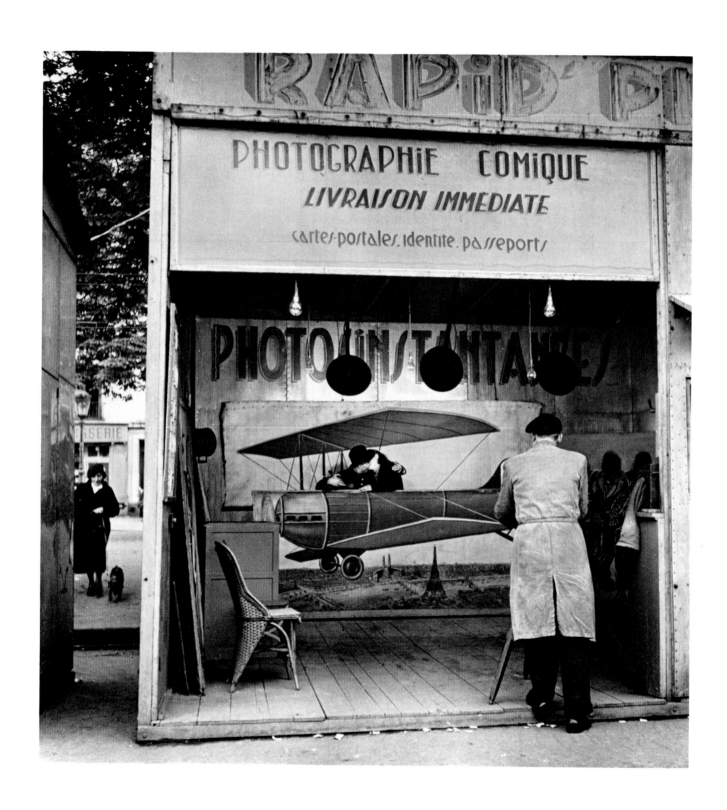

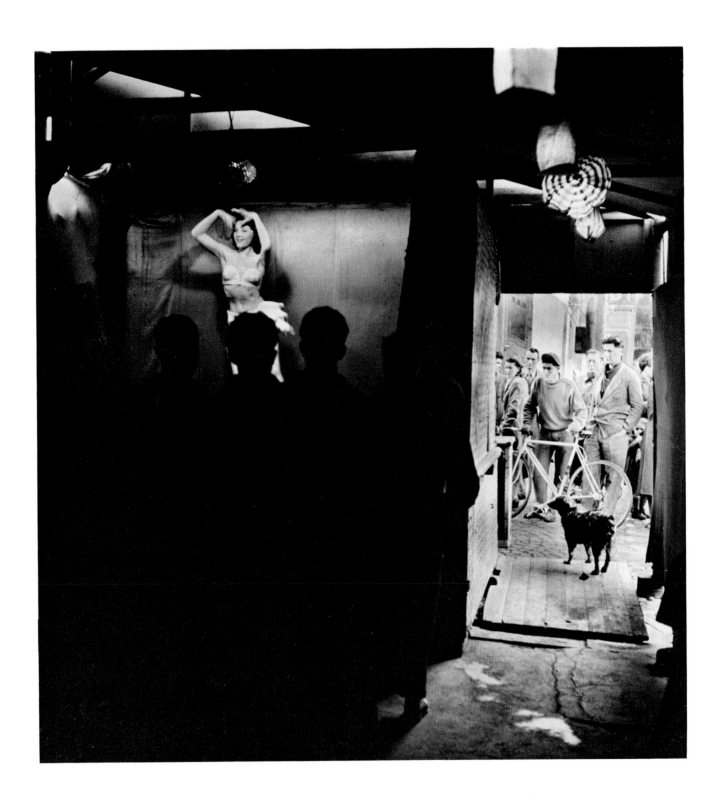

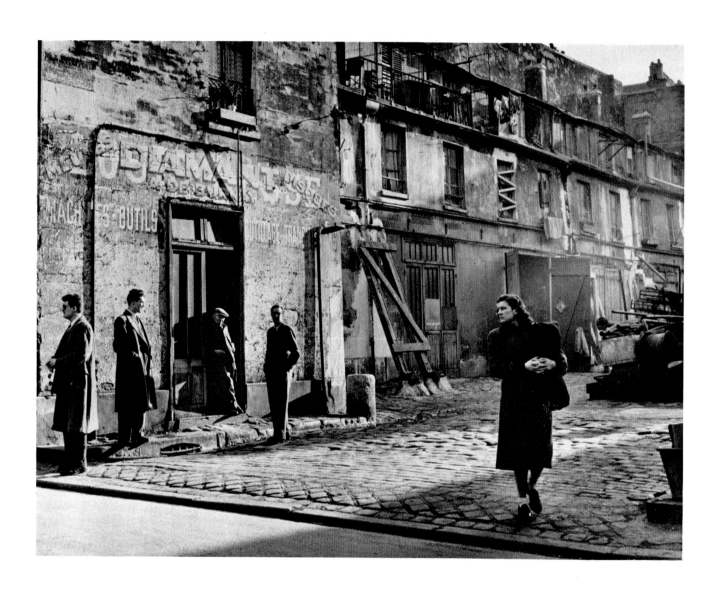

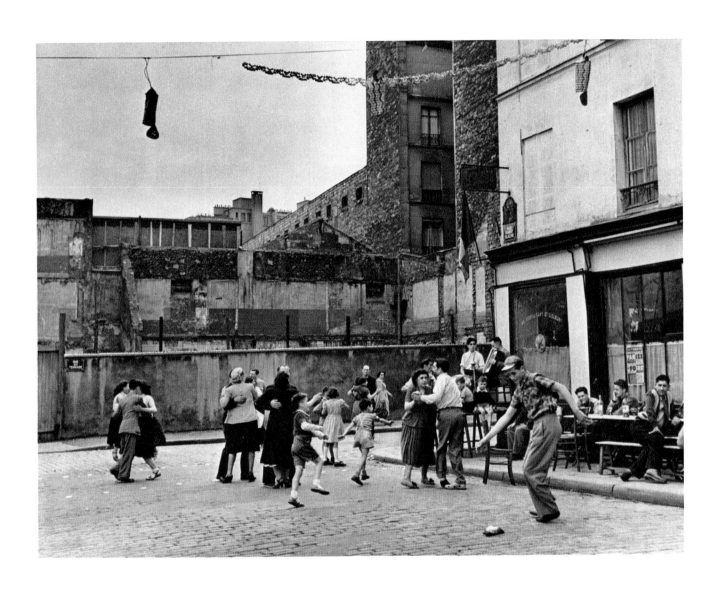

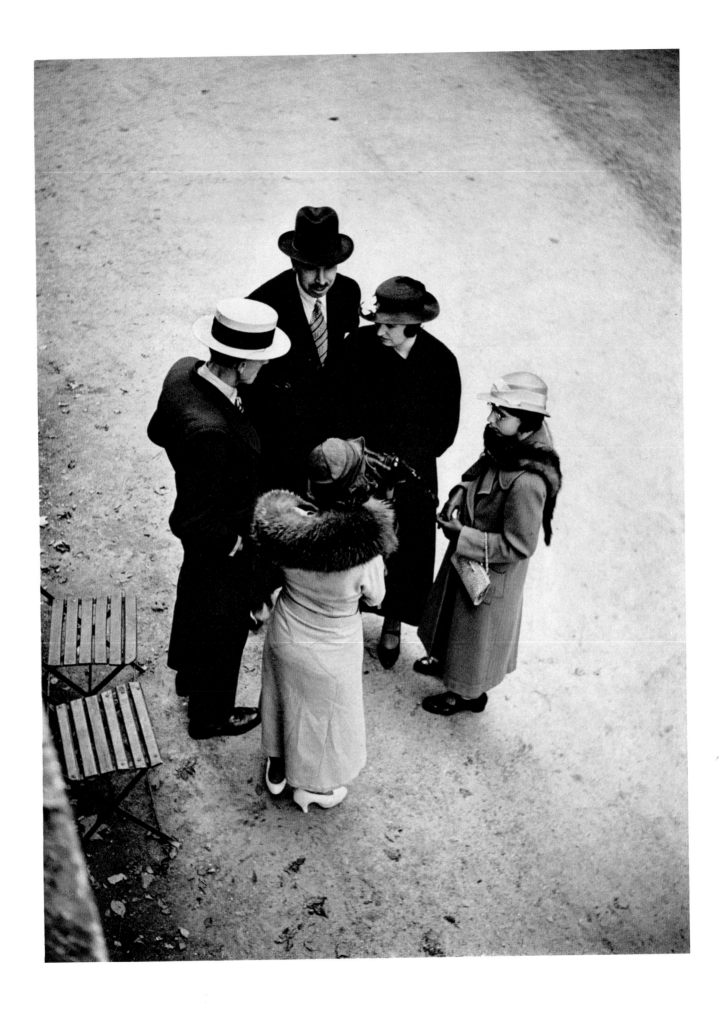

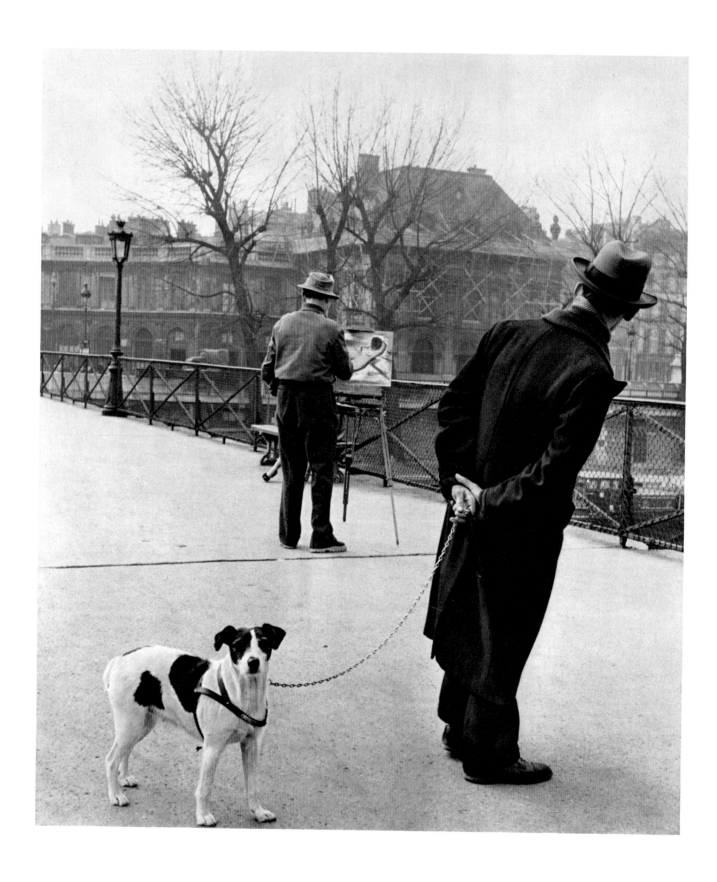

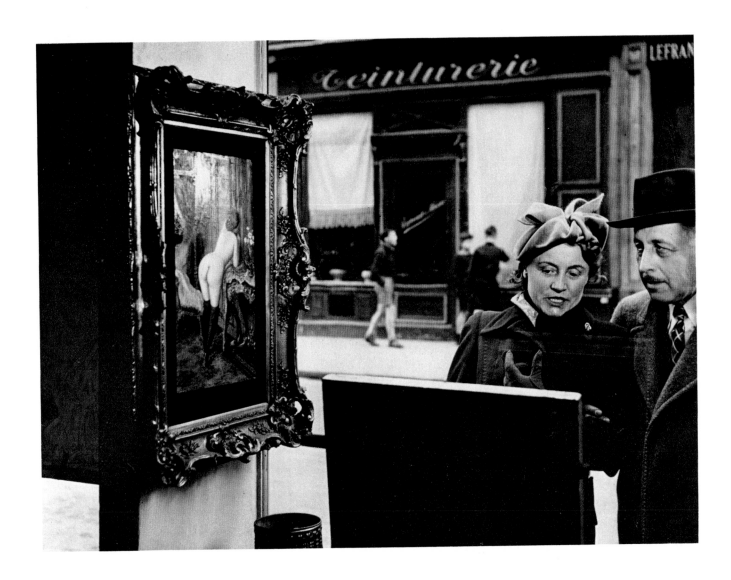

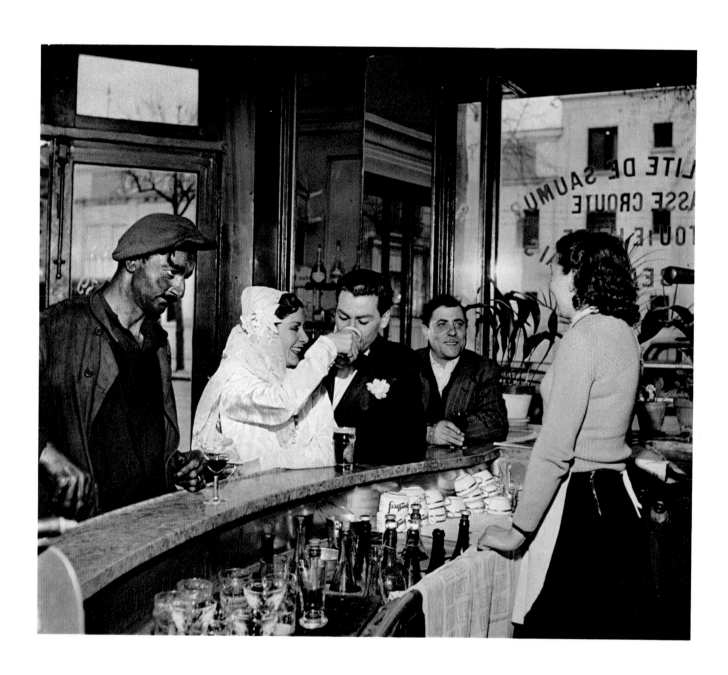

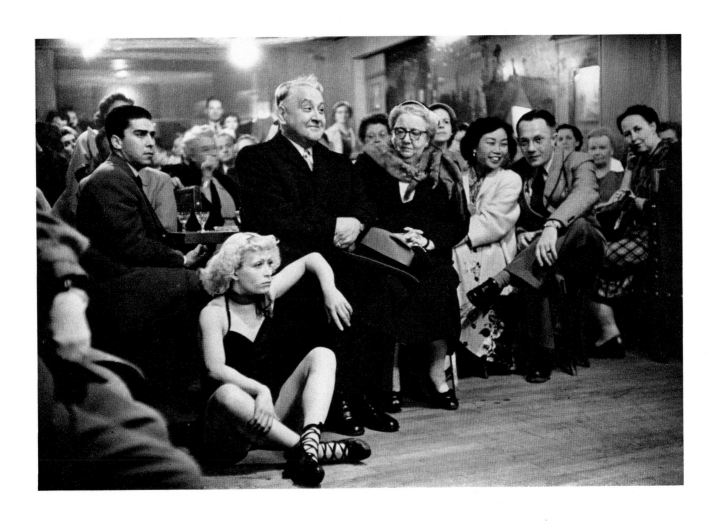

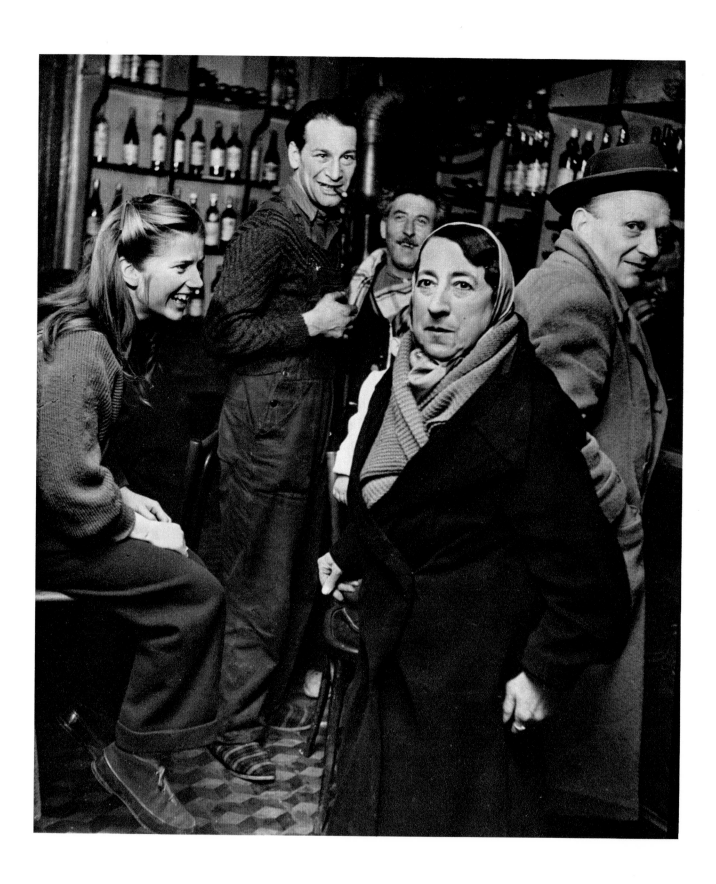

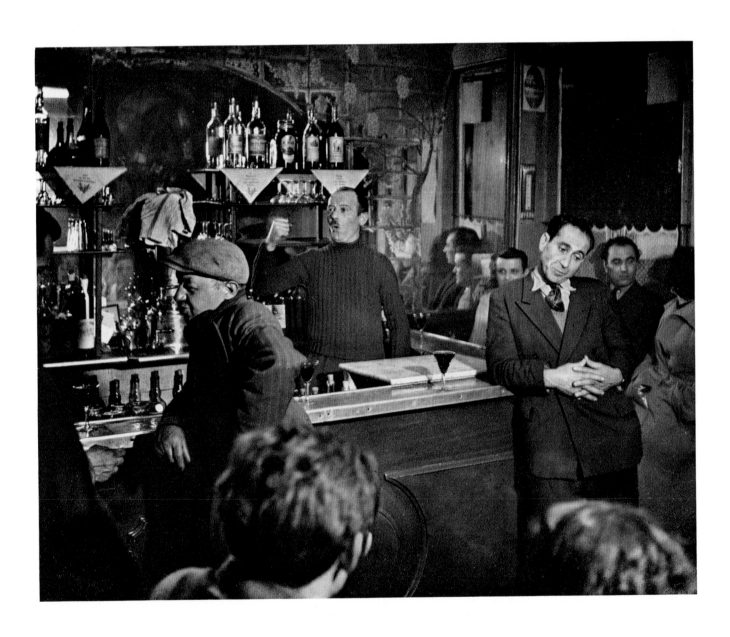

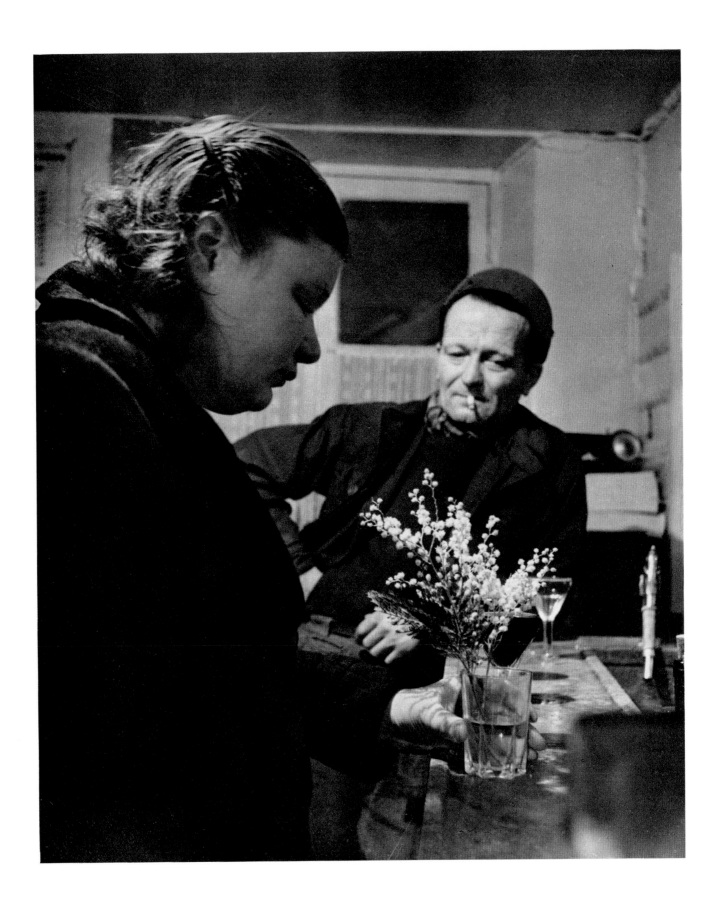

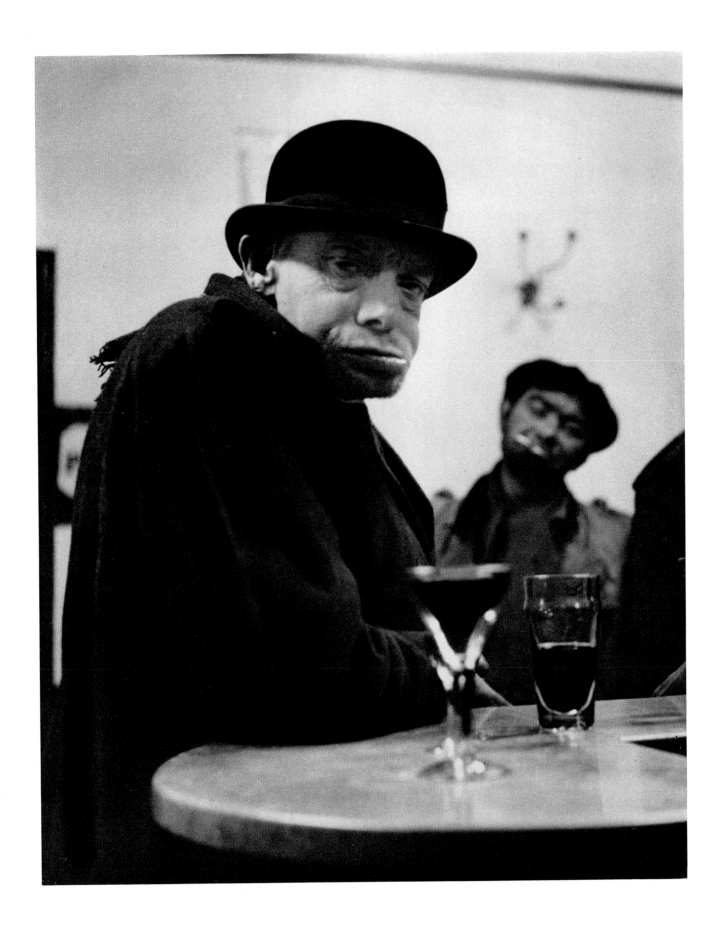

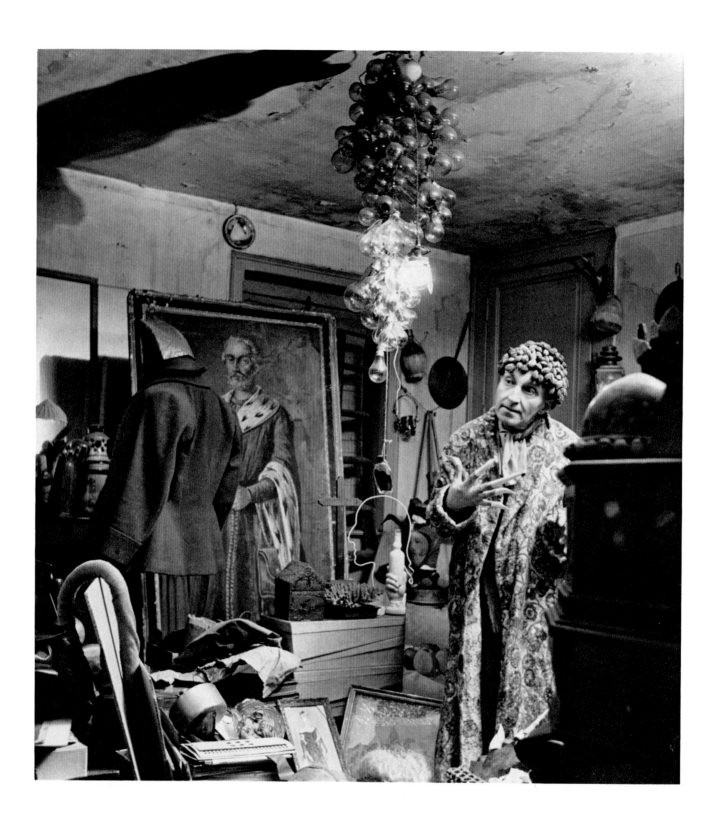

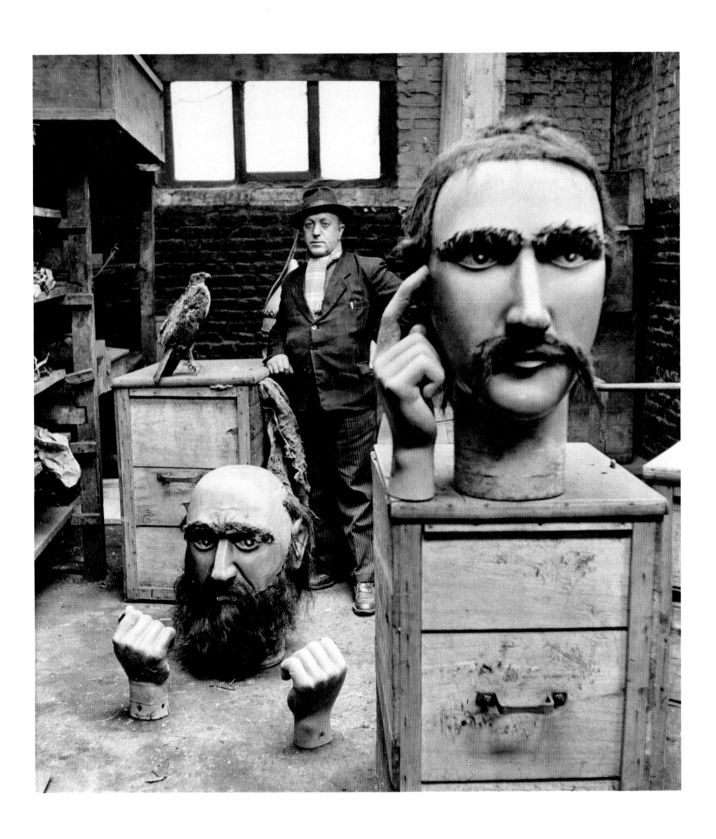

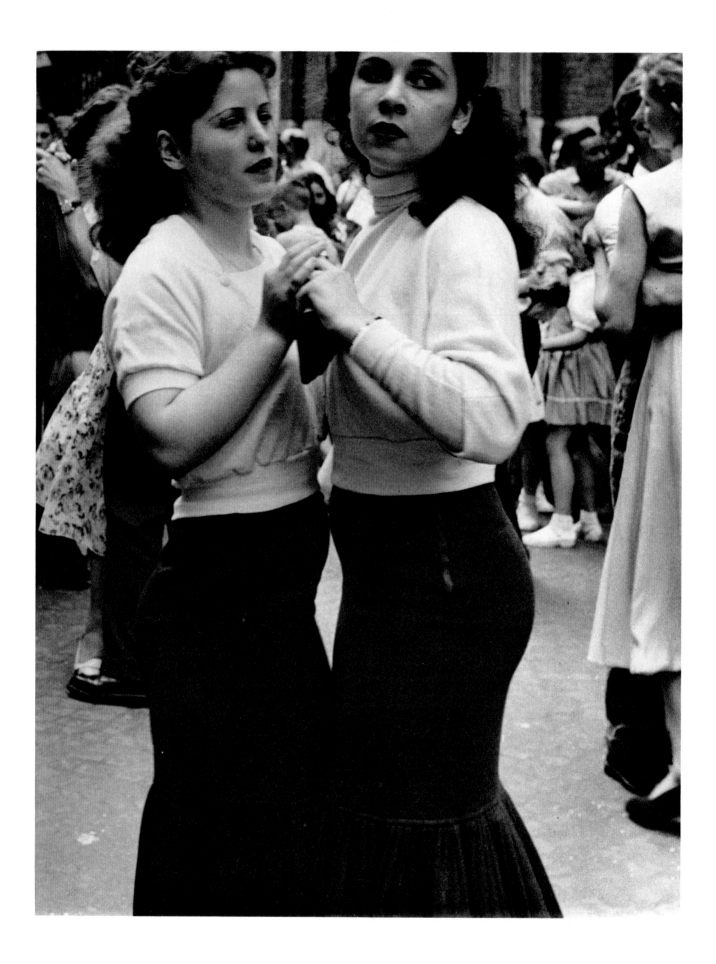

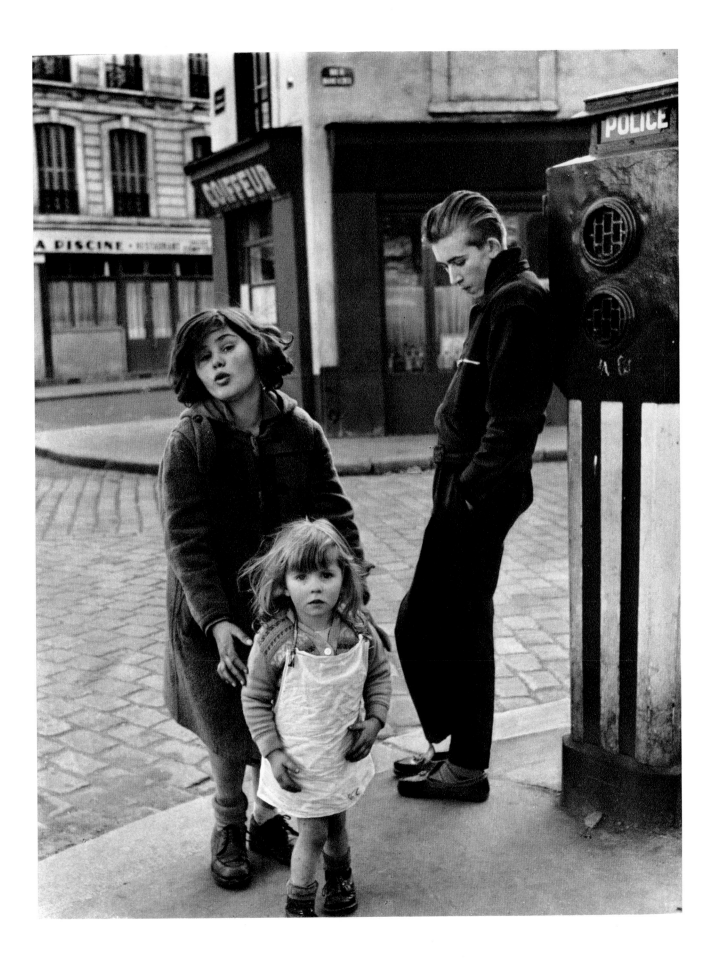

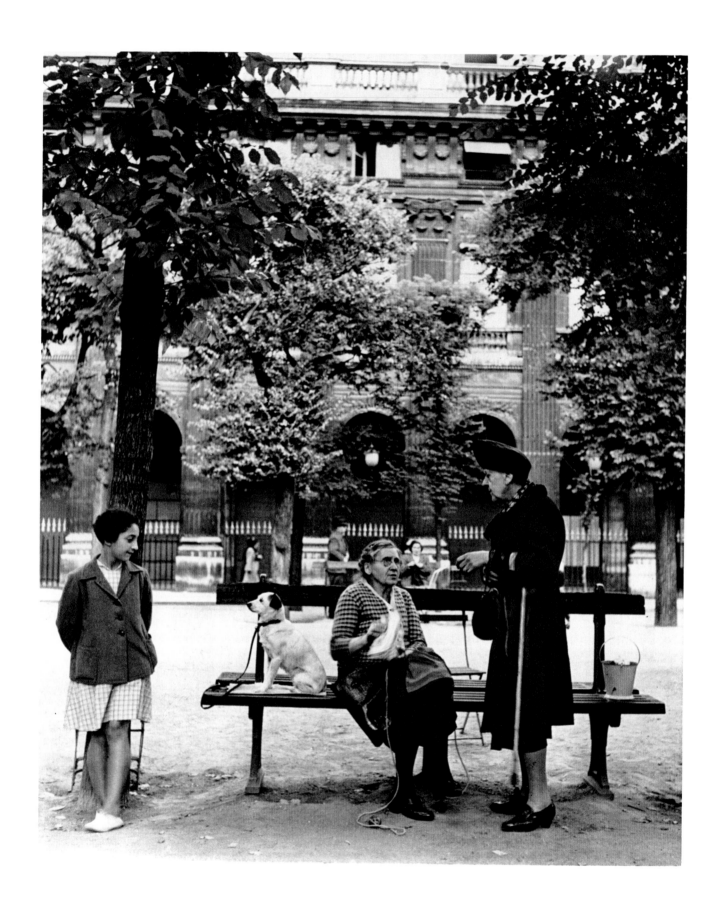

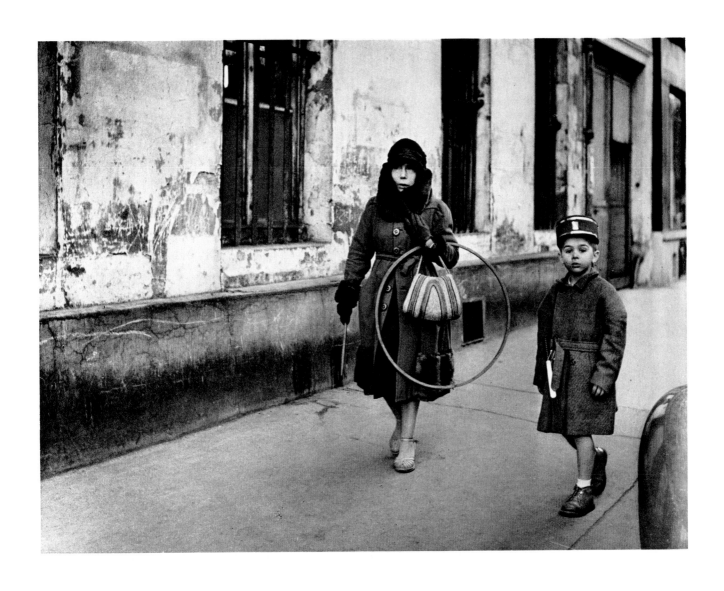

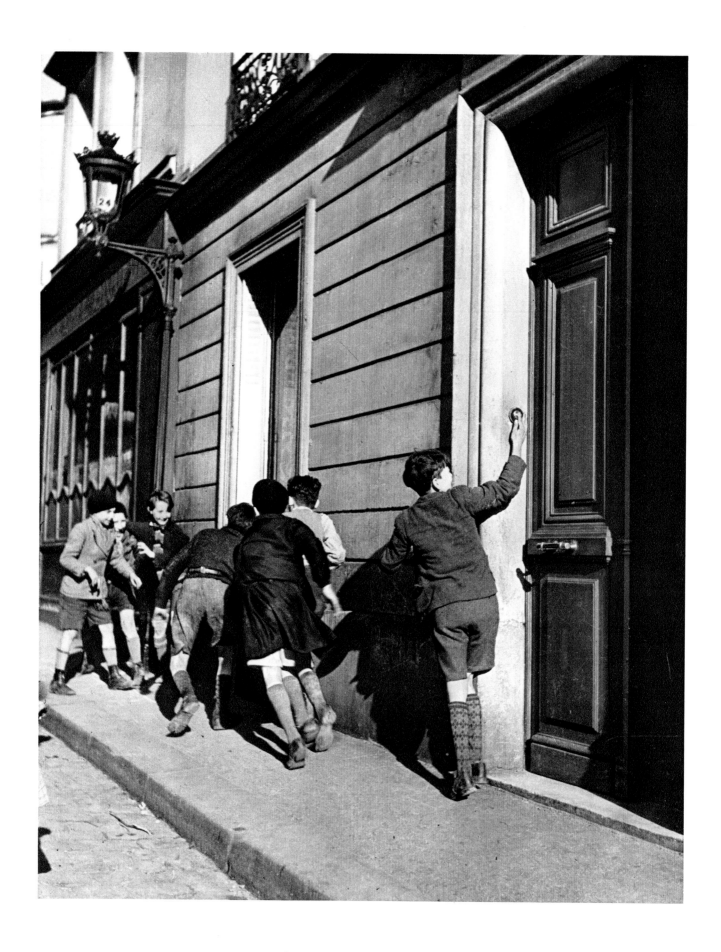

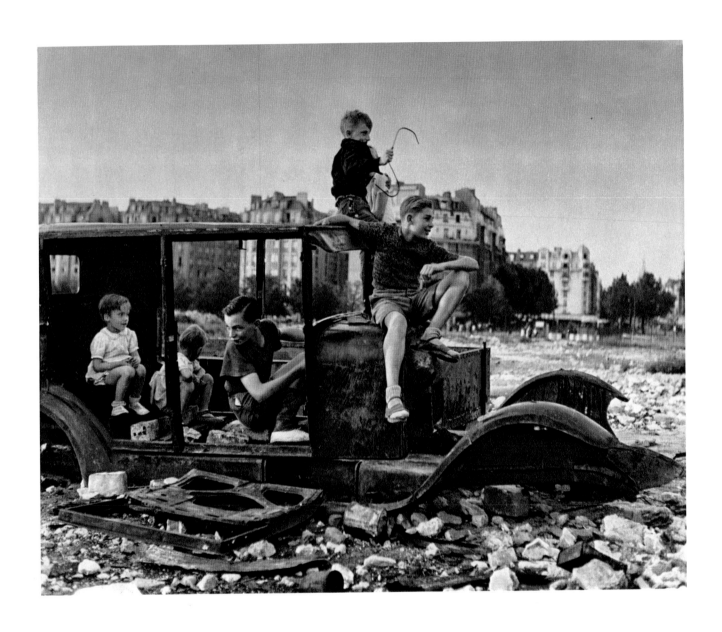

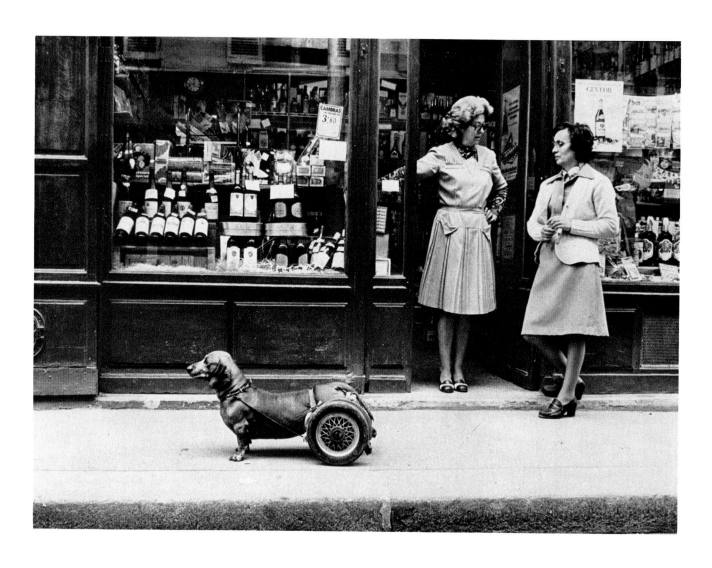

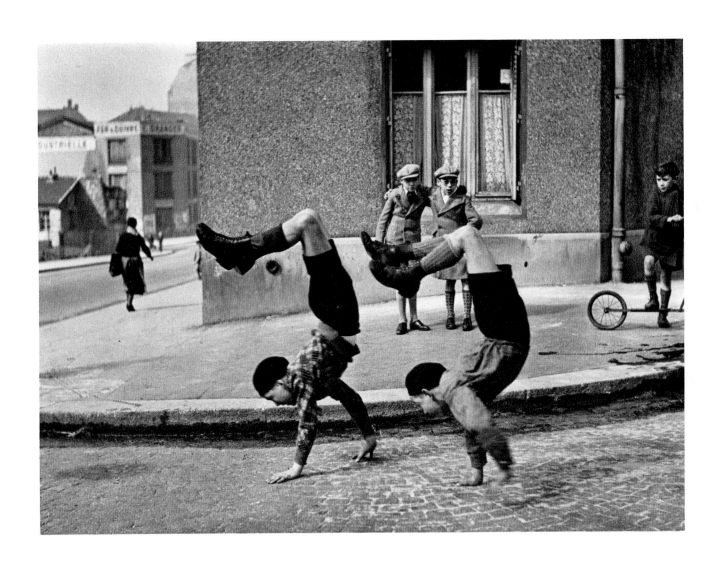

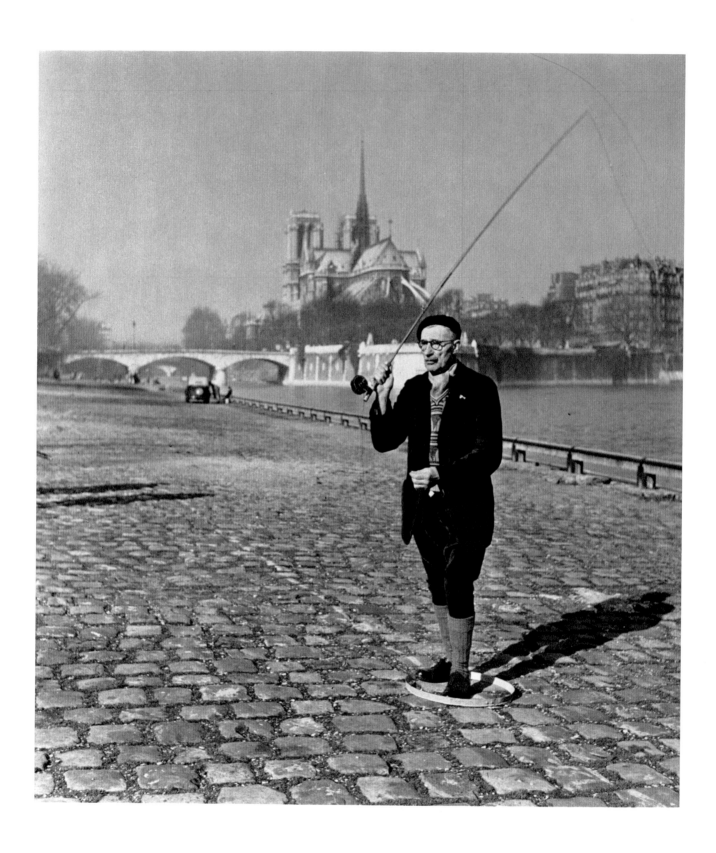

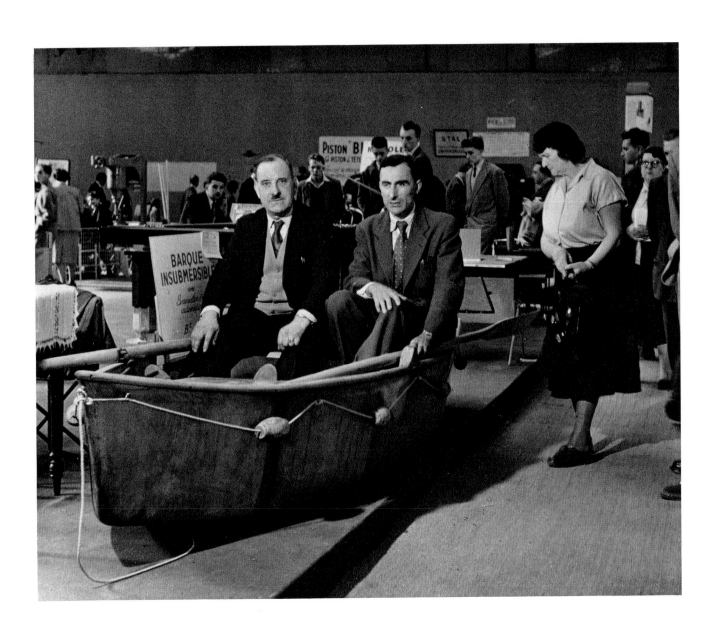

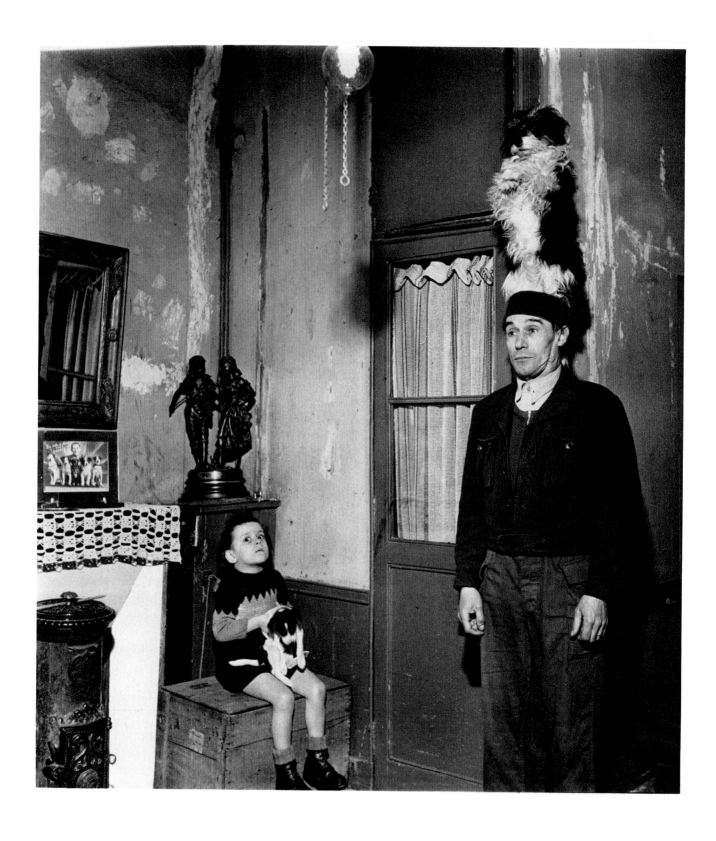

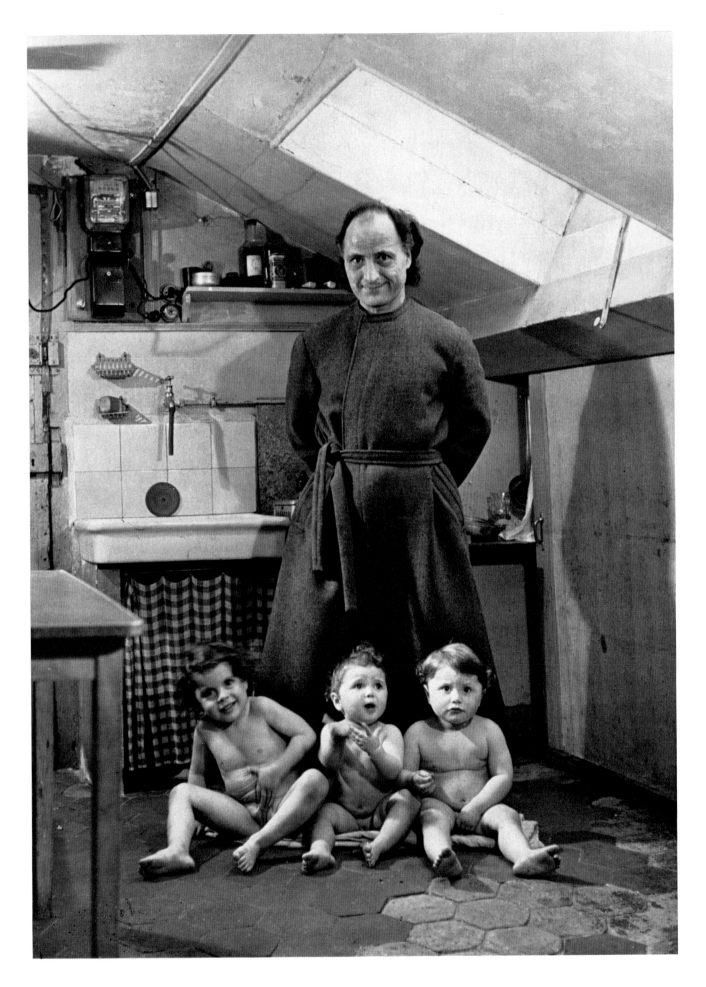

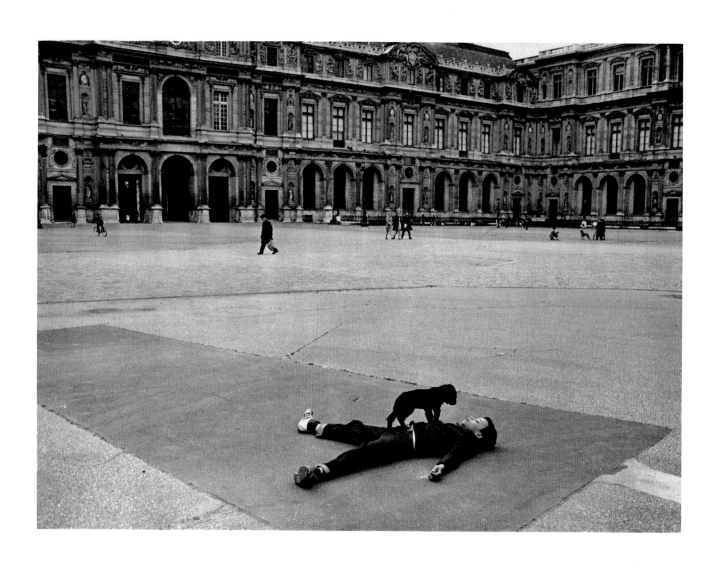

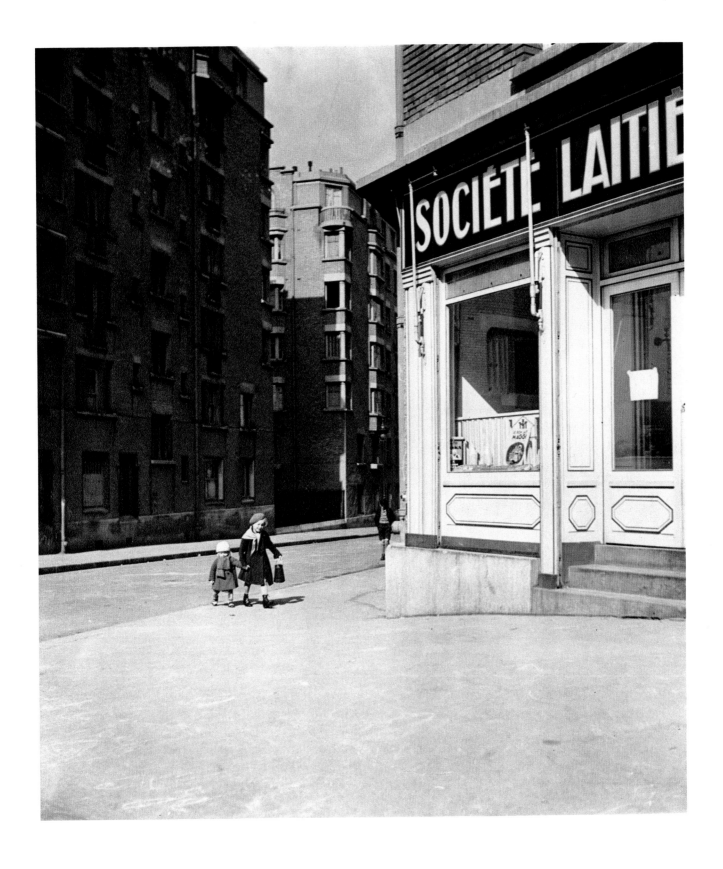

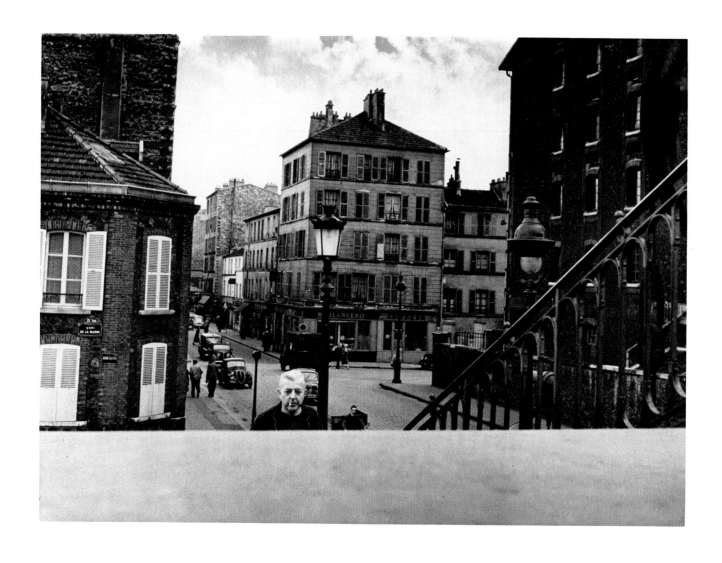

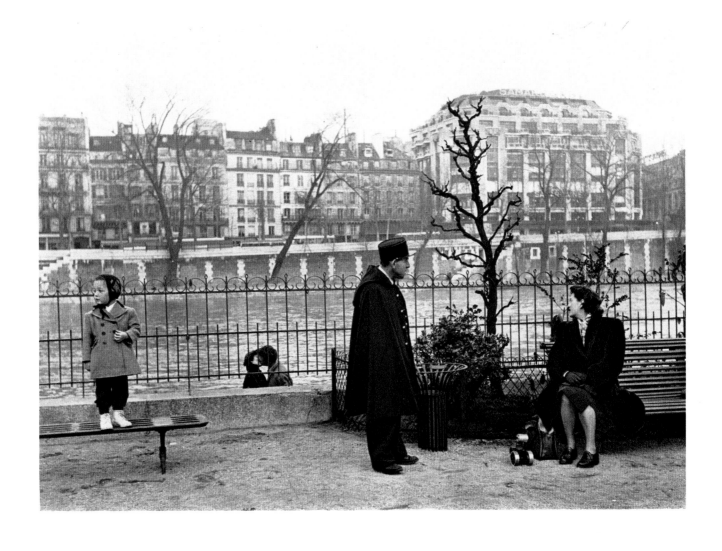

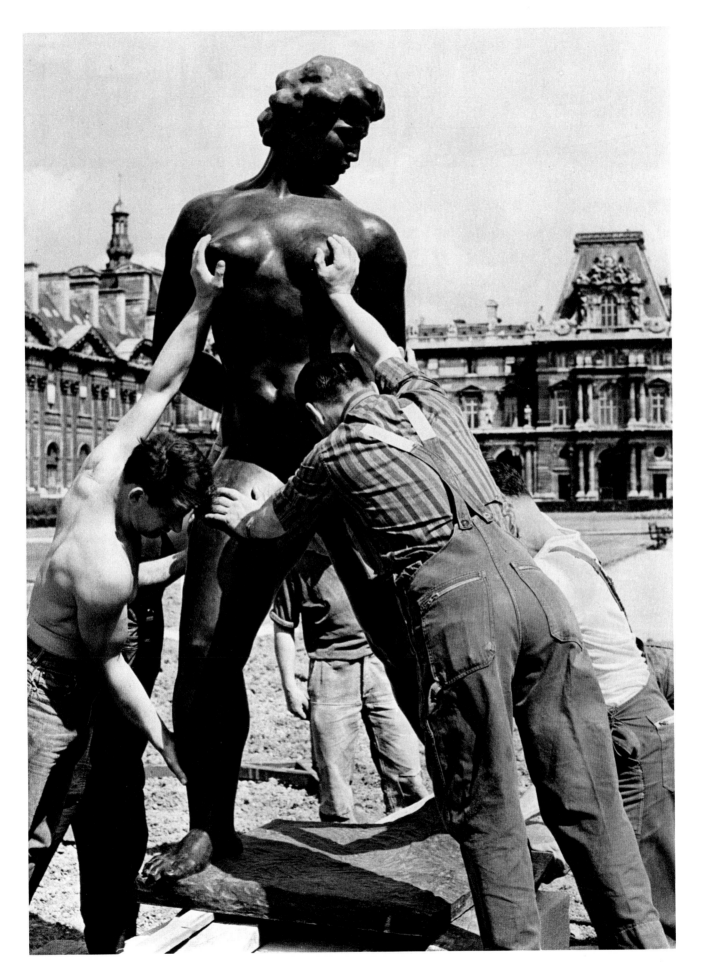

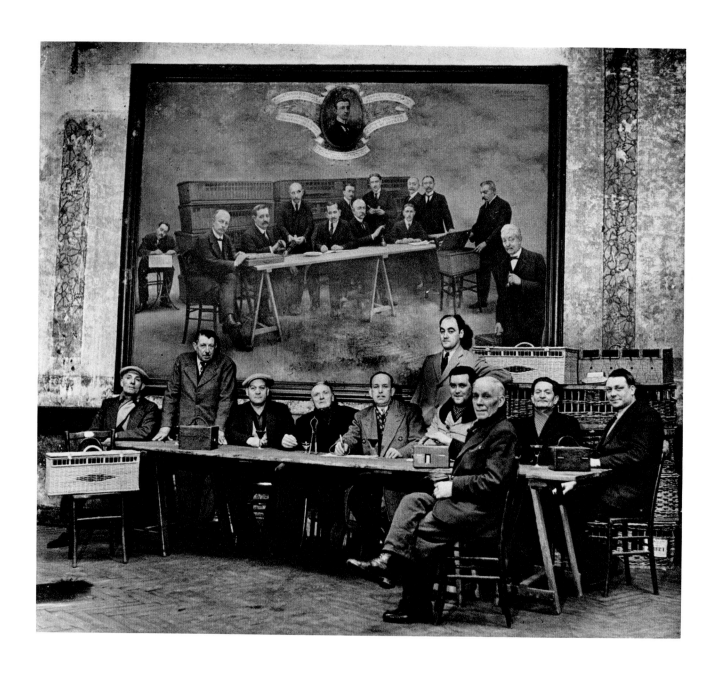

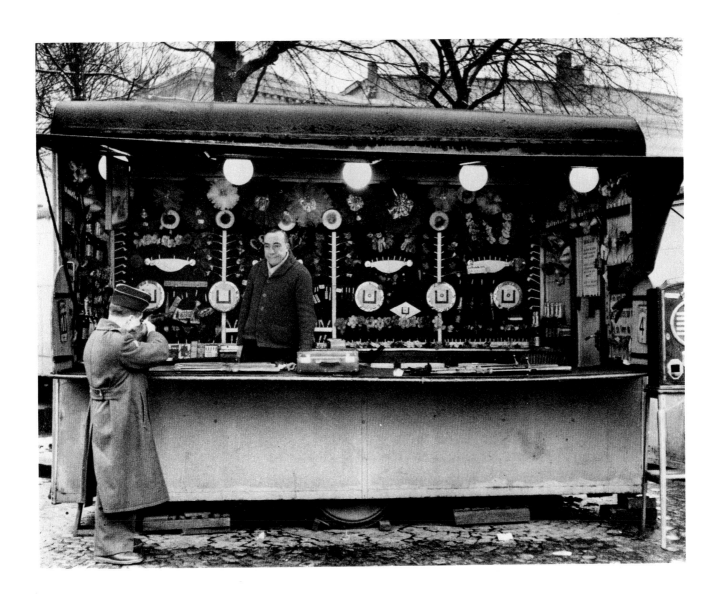

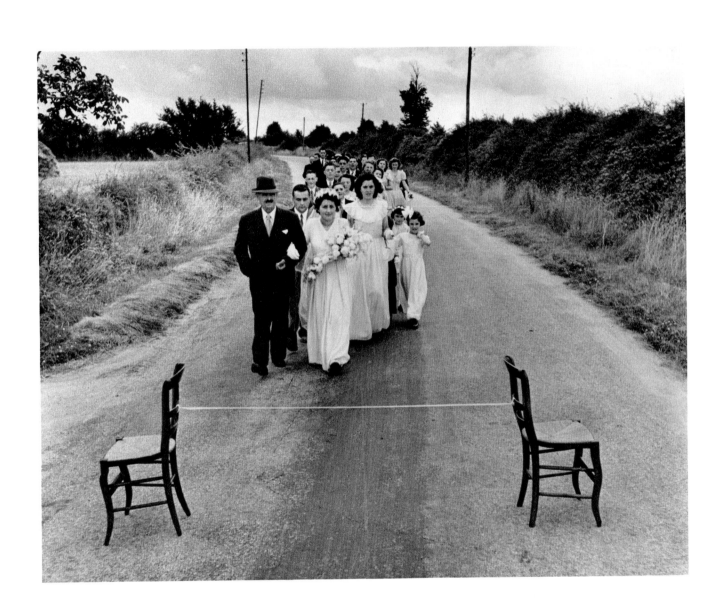

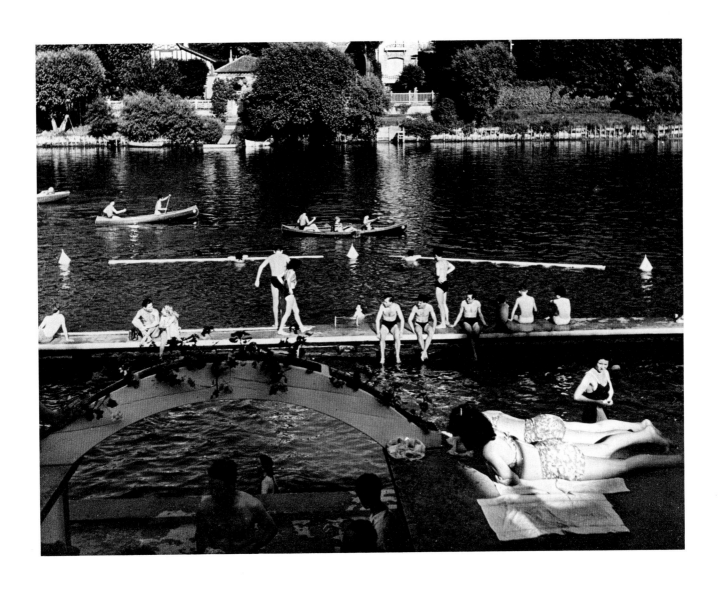

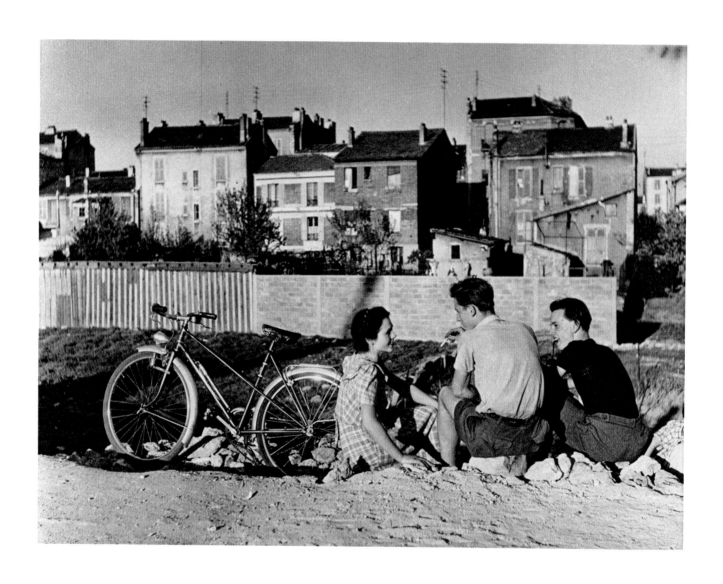

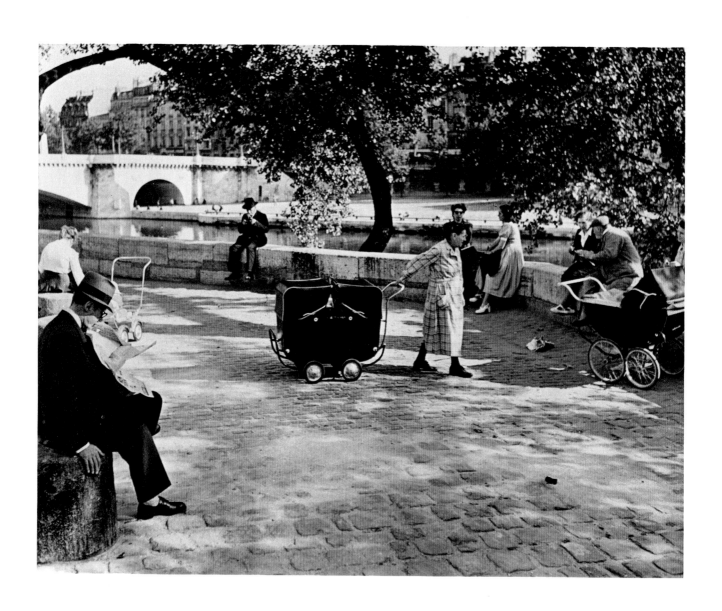

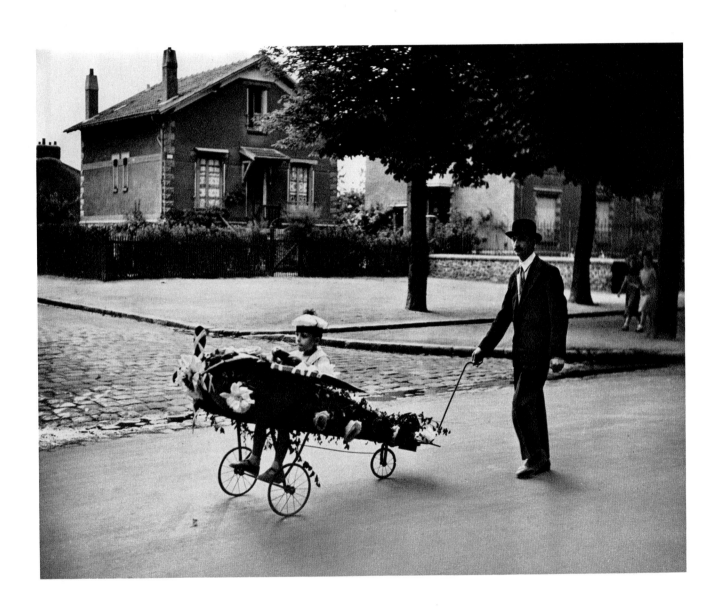

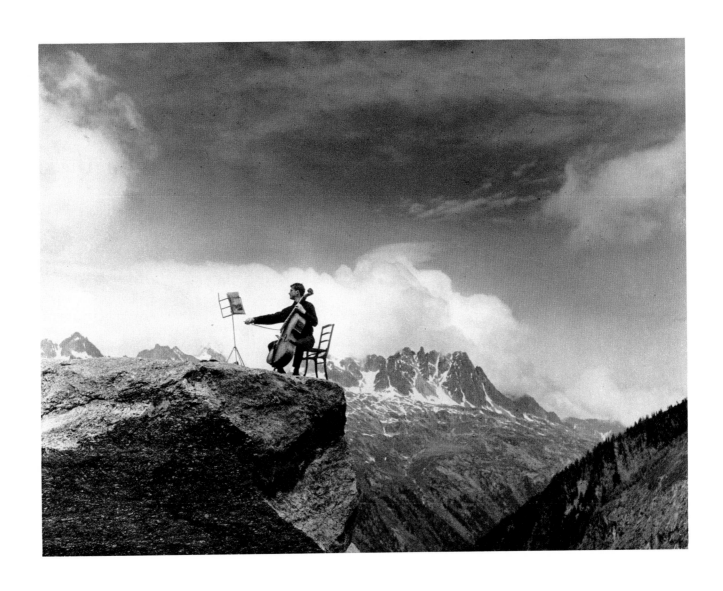

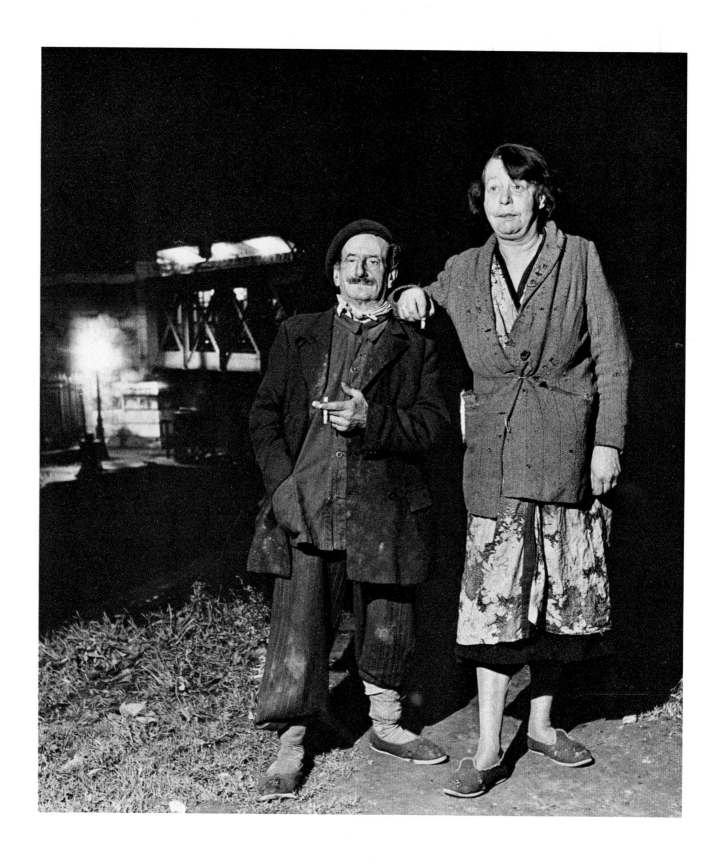

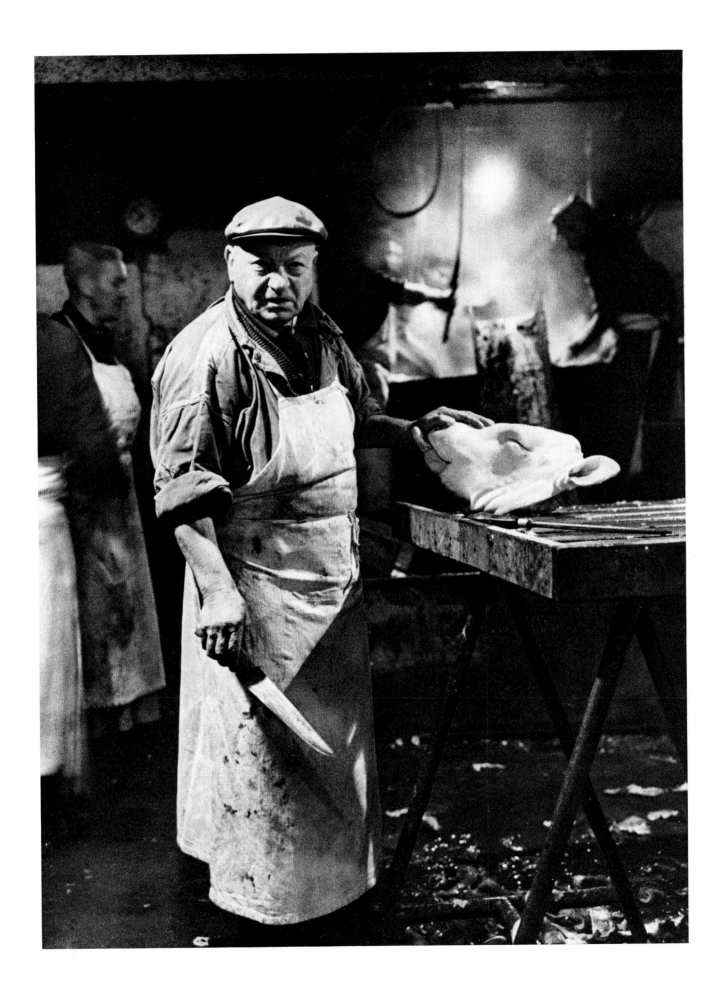

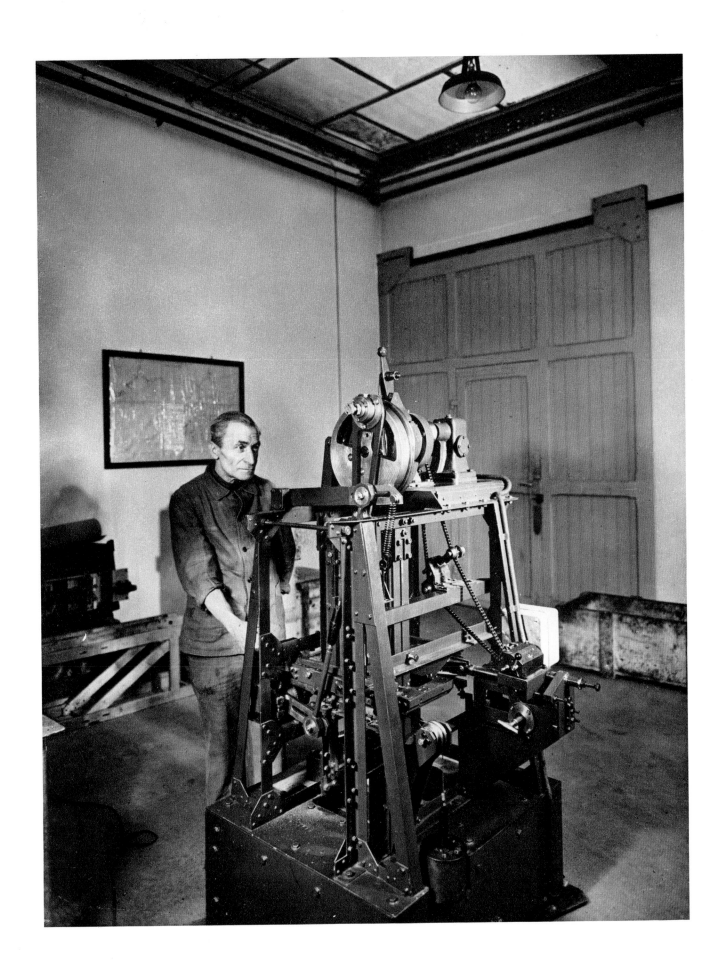

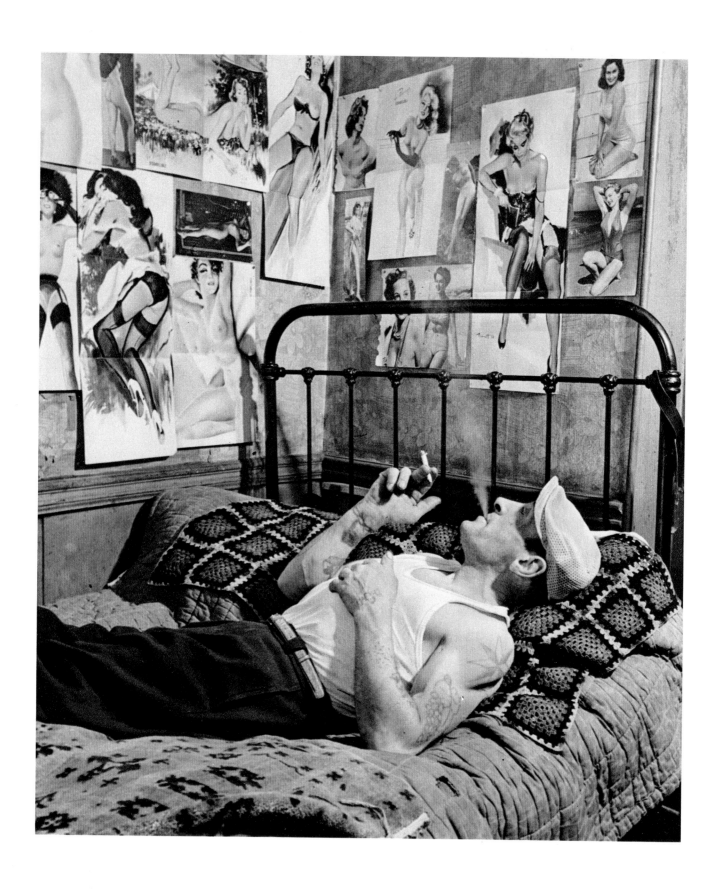

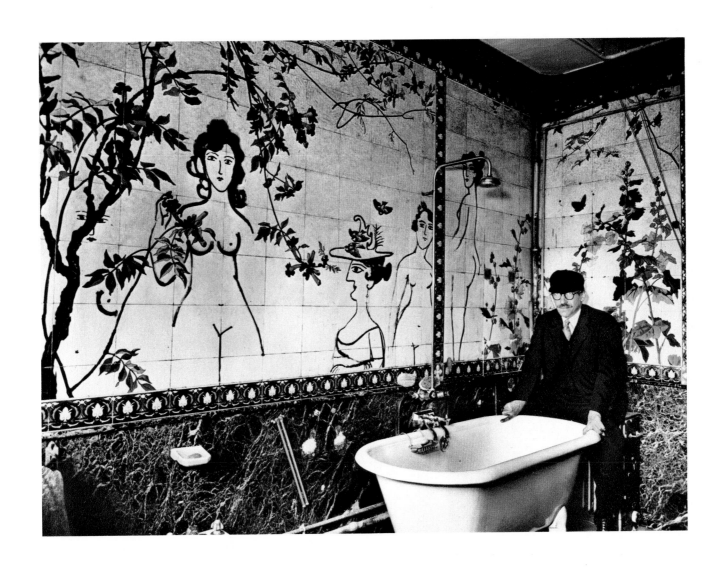

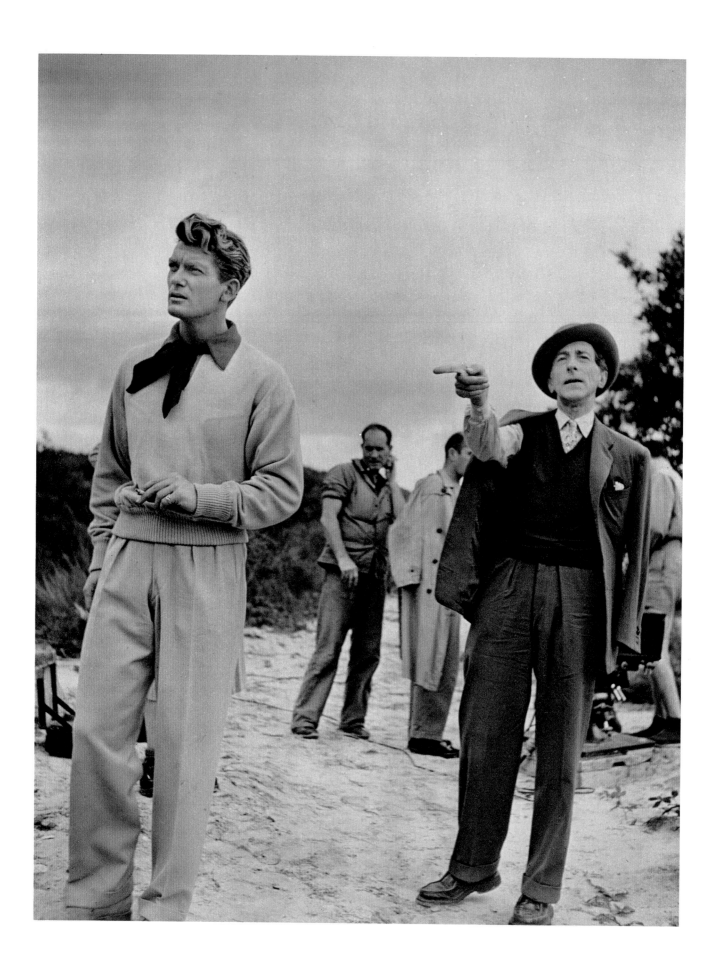

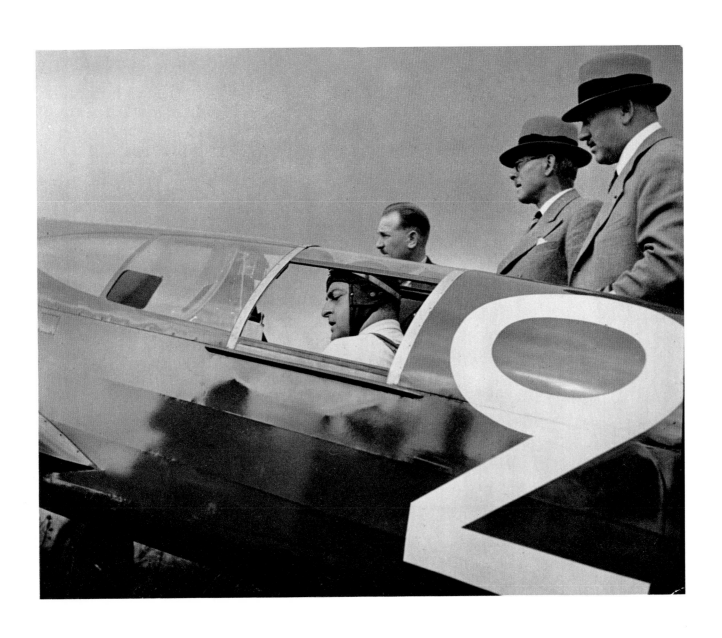

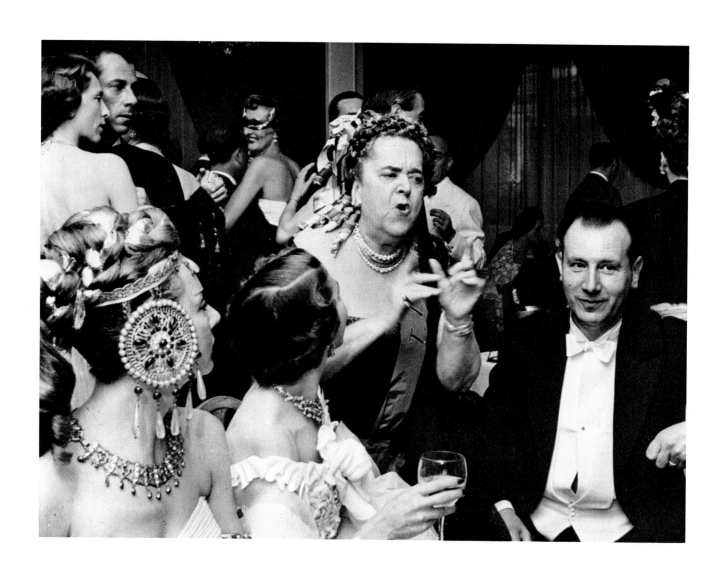

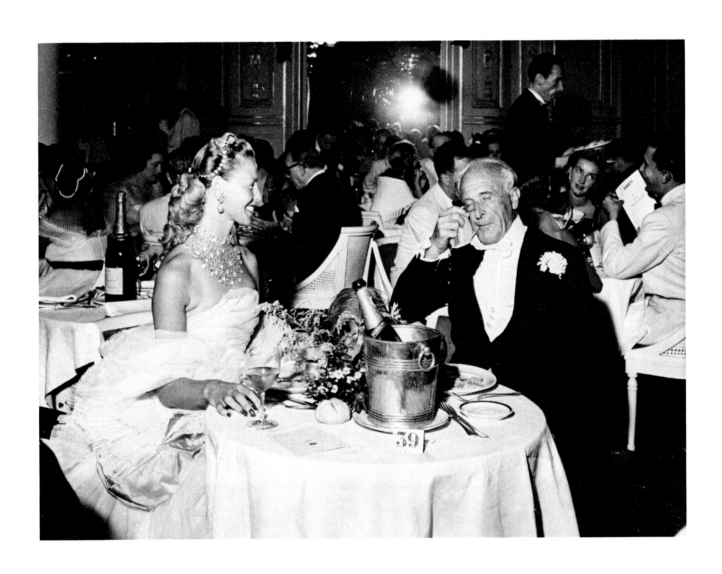

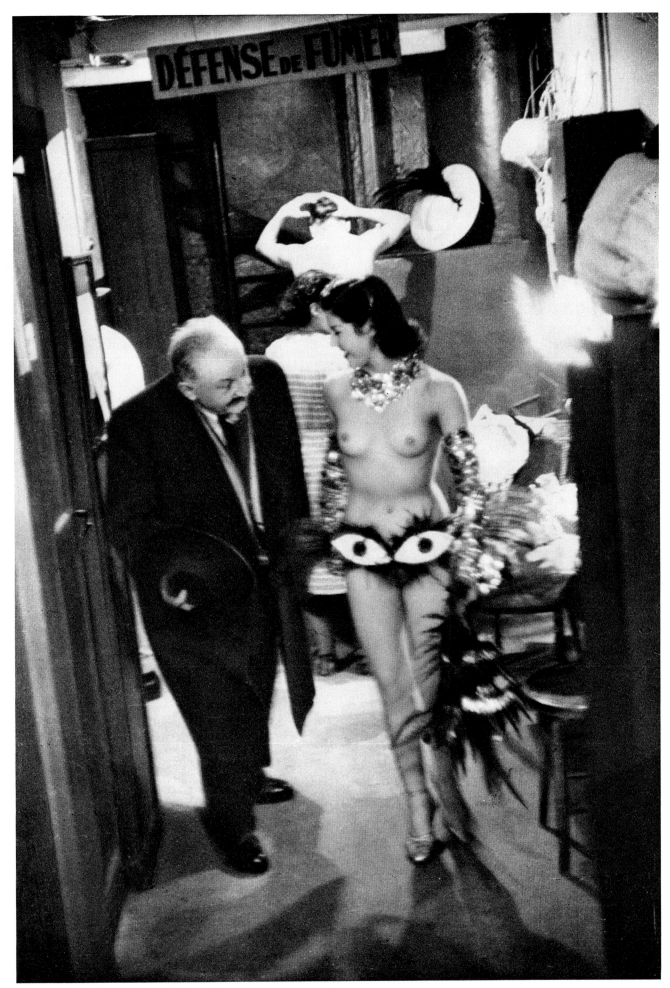

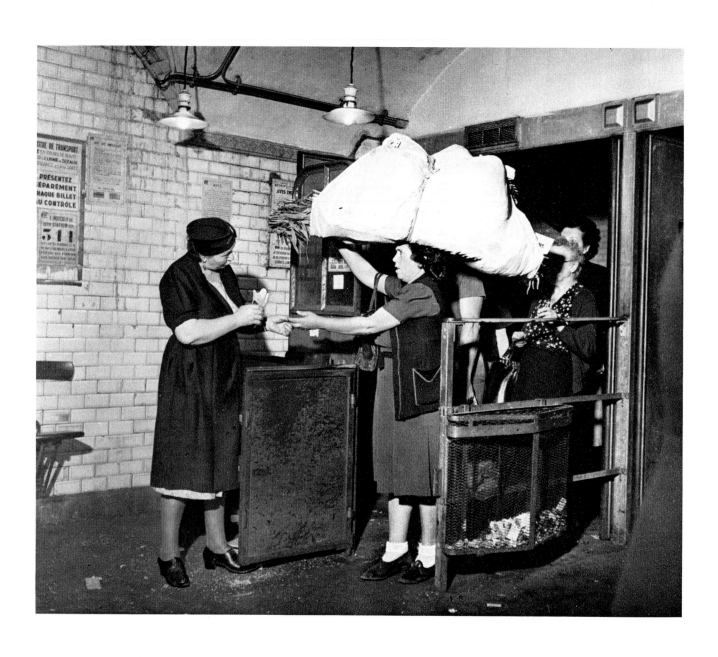

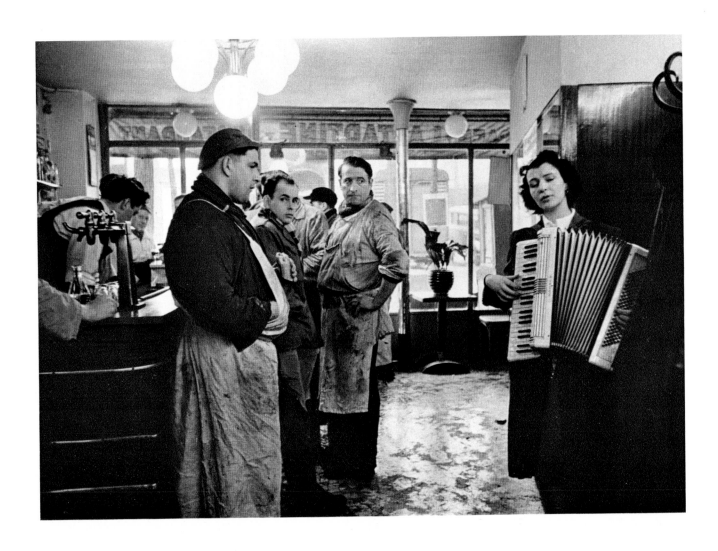

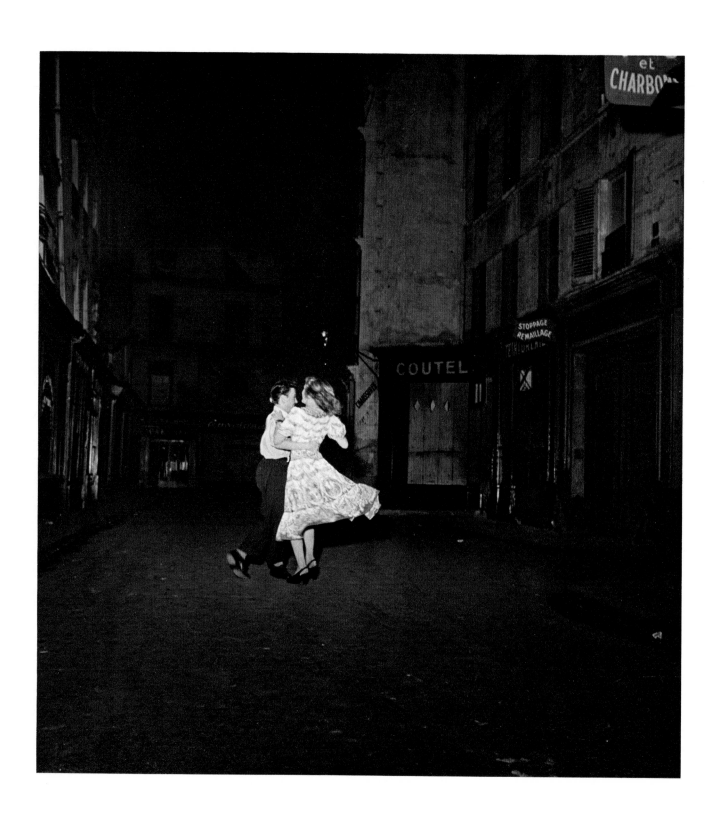

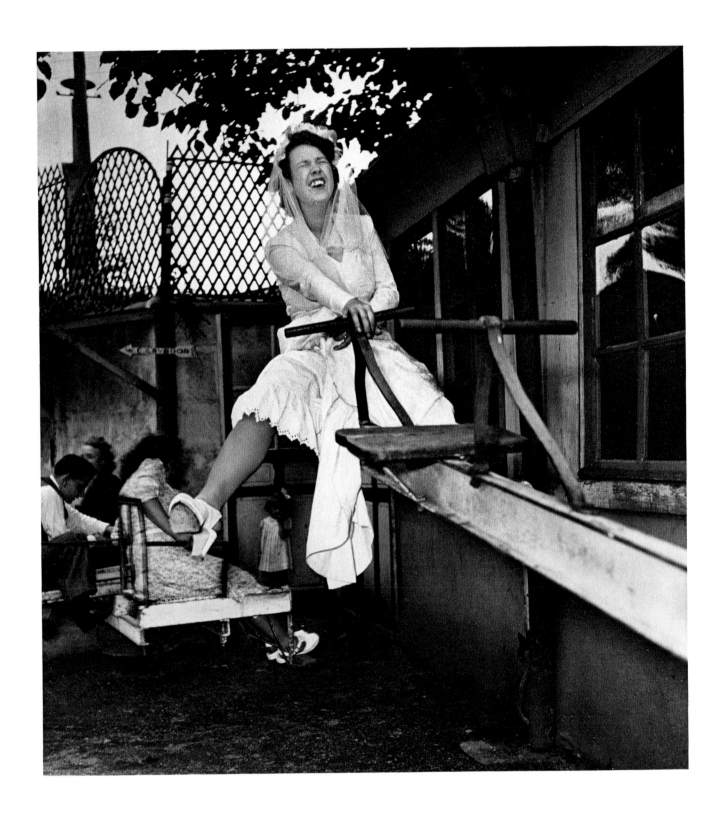

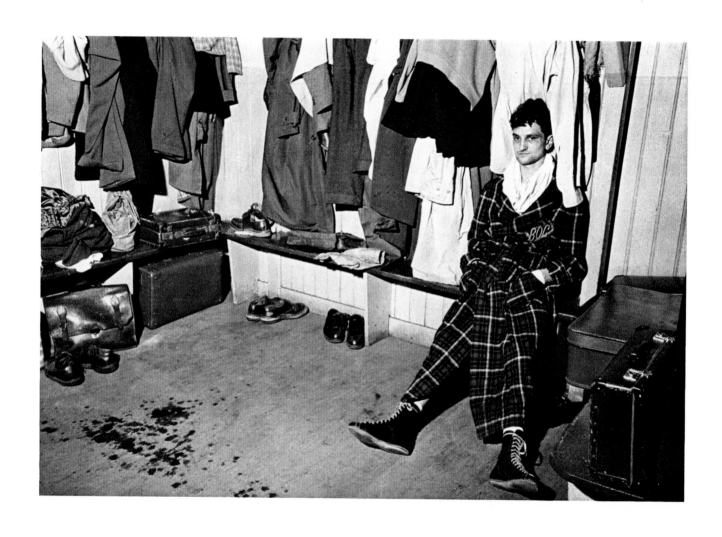

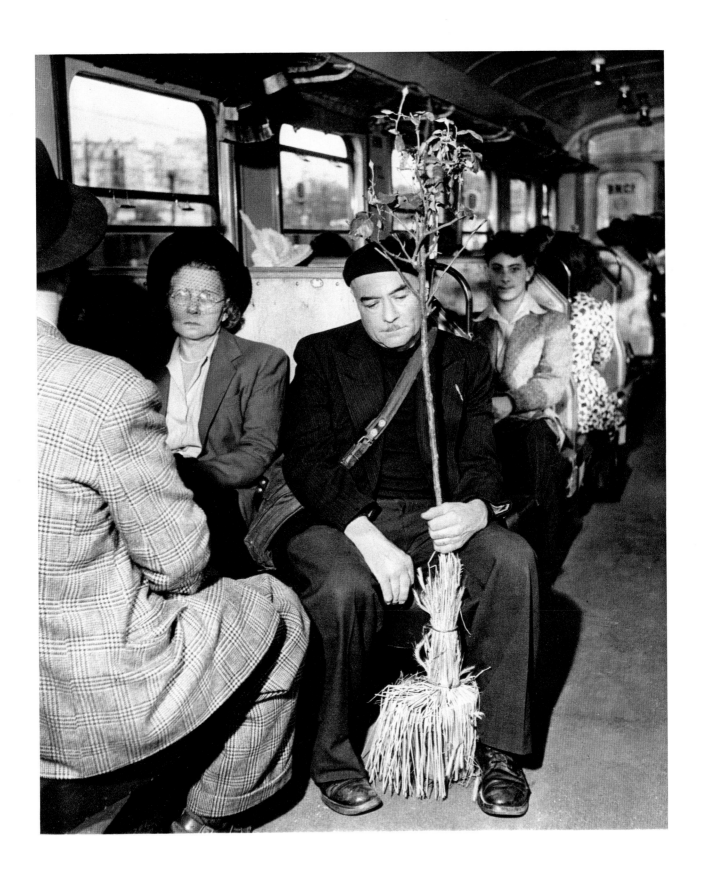

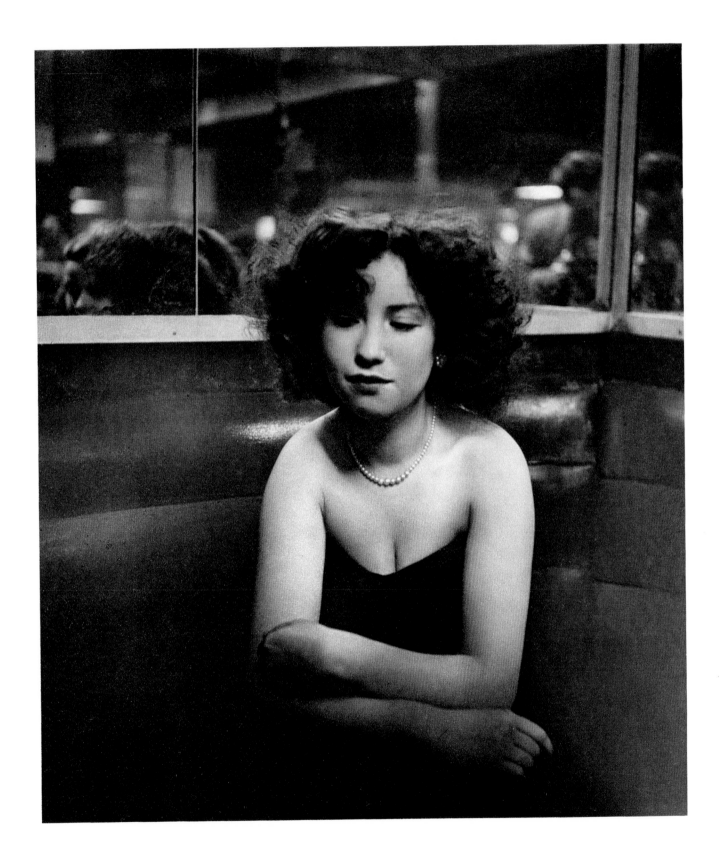

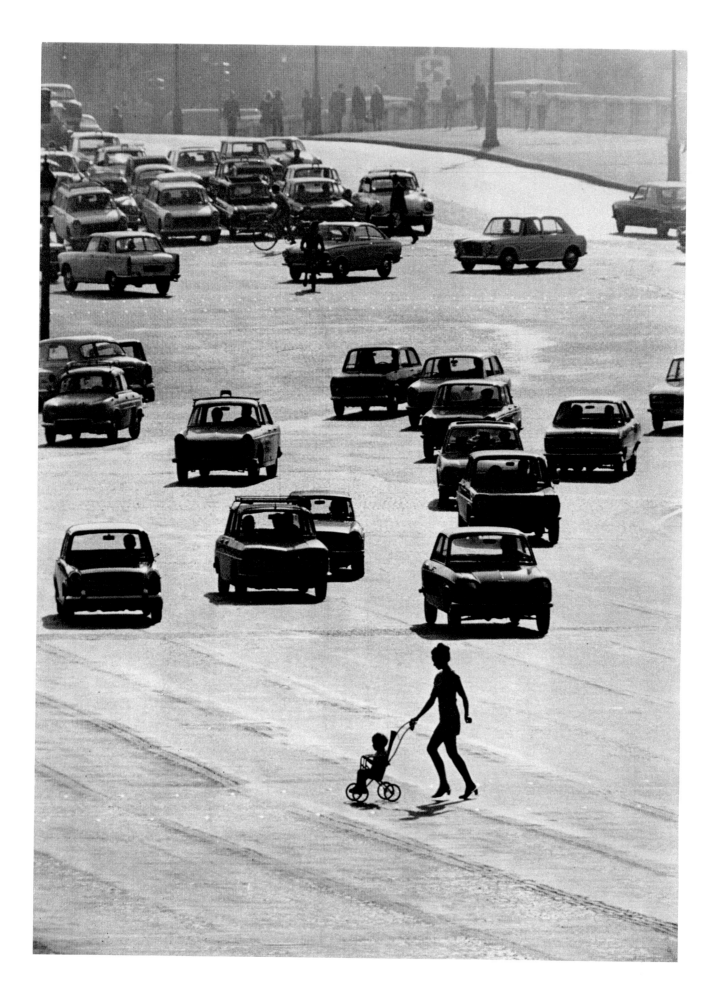

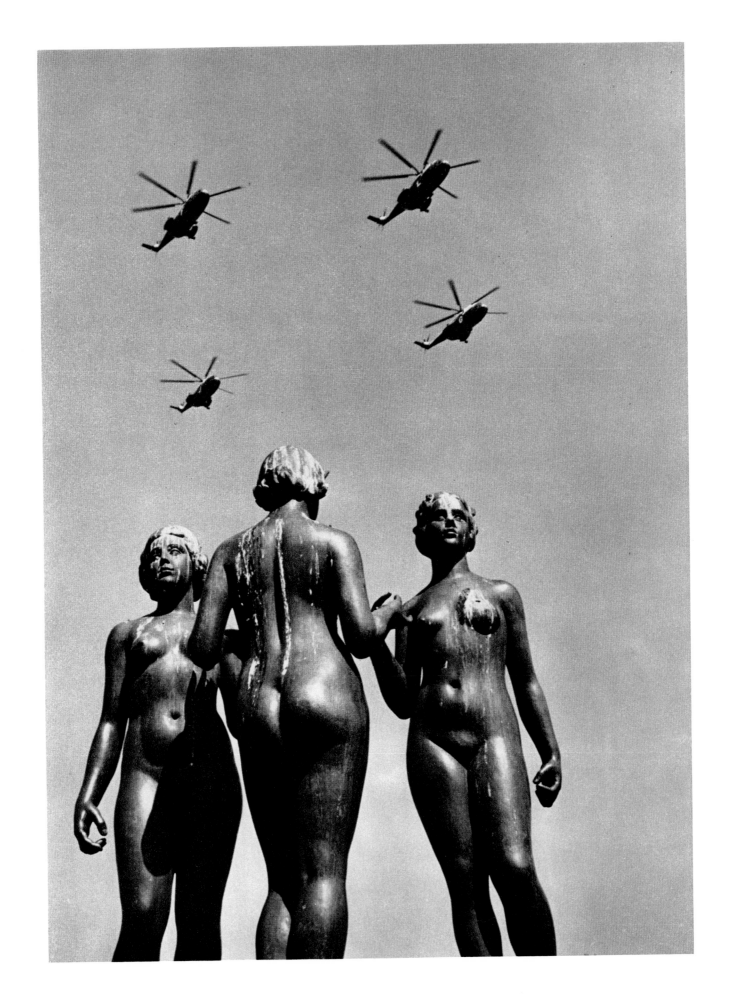

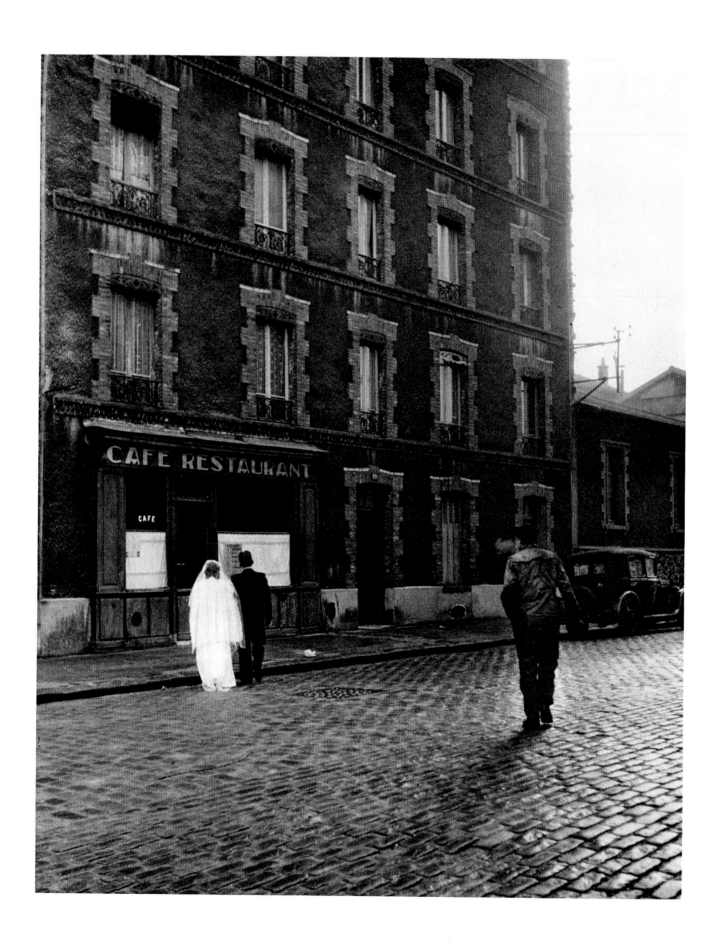

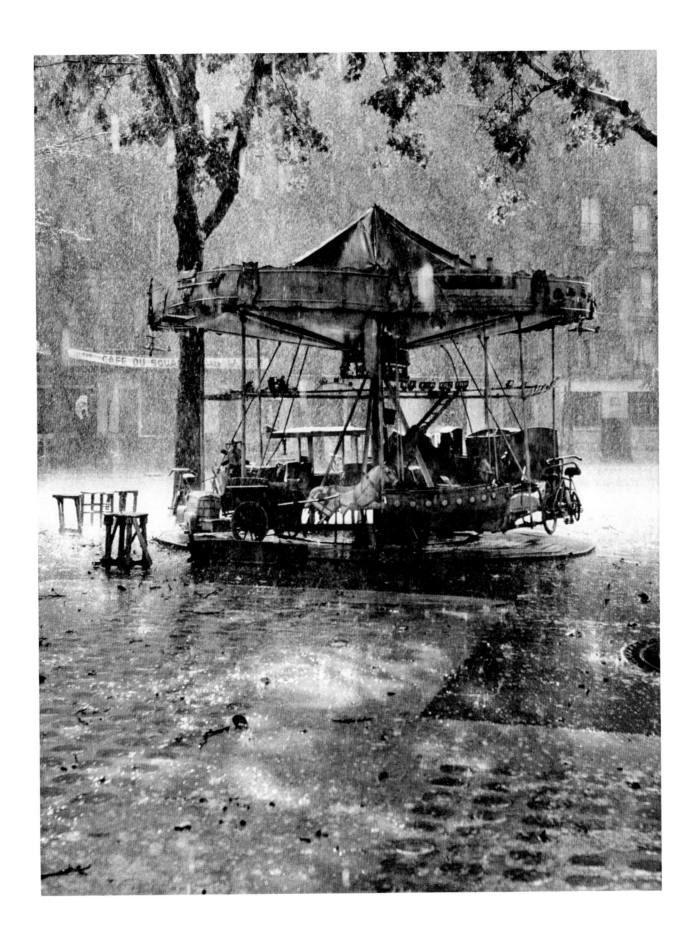

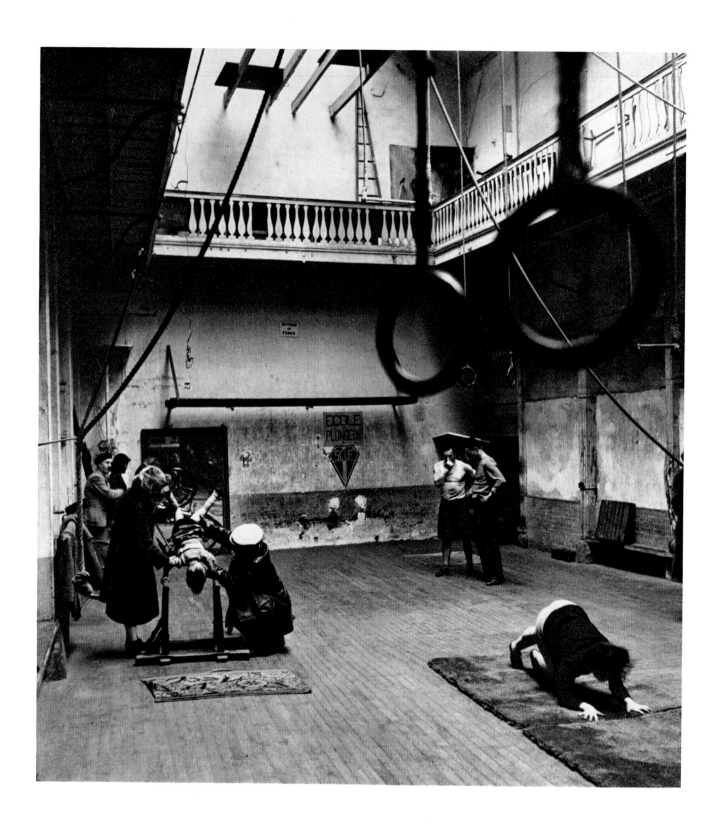

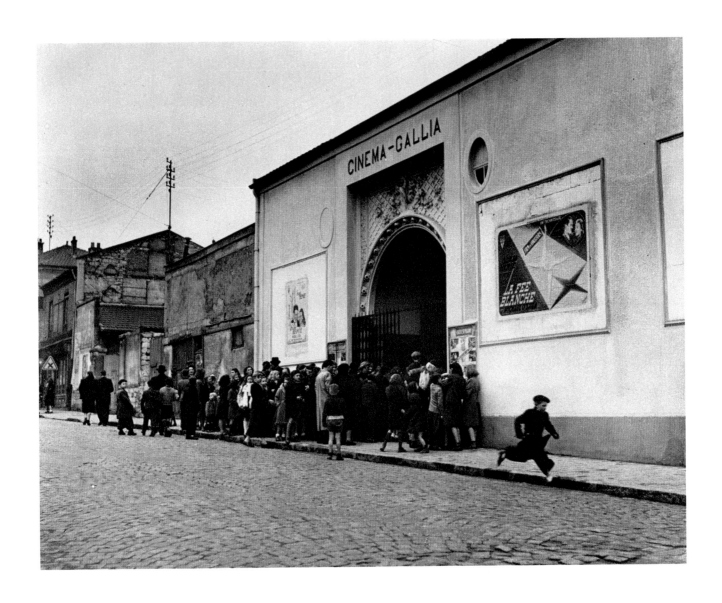

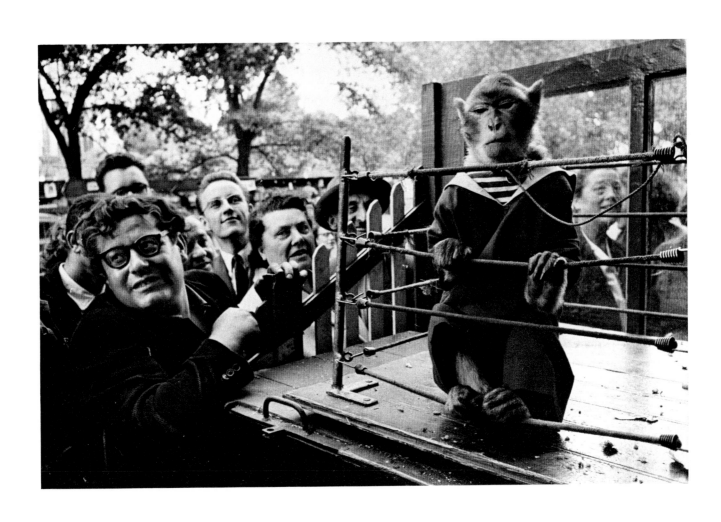

ACHEVÉ D'IMPRIMER LE 15 OCTOBRE 1979
SUR LES PRESSES DES IMPRIMERIES A. HUMBLOT A NANCY.